"Only Joan Marans Dim could take a subject as seemingly prosaic as a statue and turn it into a story of hope, hustle, history, and heartbreak. As a former director of the American Jewish Congress, I was privileged to hear firsthand many stories of those Jewish immigrants who had the courage to make the perilous journey across the Atlantic to escape the humiliations of *pogroms* and persecutions. One can only imagine their joy when they first saw Lady Liberty—a statue that embodied their only hope of a free and decent life. Those stories—coupled with the evocative paintings of Antonio Masi—remind us of the goodness of America and the vital role that all those immigrants played in making America truly great. Now, at a time when immigrants are being attacked, *Lady Liberty* is a must-read."

—Naomi Levine, former Senior Vice President, New York University;
former Executive Director, American Jewish Congress

"This is a masterful treatment of the Statue of Liberty and its origins, construction, and symbolism, as a framework for telling the dramatic stories of those who created it. The tale is set in context of its significance to the immigrant experience and the country's immigration policies. Joan Marans Dim, the writer, and Antonio Masi, the watercolorist, are a brilliant match to tell and depict such a vibrant and dramatic story. This book is unique."

—Dr. Diane Fairbank, previously Director of Writing and Research,
University Relations, and Public Affairs at New York University

"The Statue of Liberty captures so much of the American story in one iconic sculpture. And you cannot understand the miracle that is America without understanding Lady Liberty. How and why did America become America? What is our secret? This new book by author Joan Marans Dim and artist Antonio Masi reveals everything."

—Walker Lundy, former Editor of the *Philadelphia Inquirer* and *Saint Paul Pioneer Press*

"Author Joan Marans Dim tells the story of Lady Liberty from conception to construction and creatively weaves the history of immigration into her engaging narrative. Watercolor artist Antonio Masi's wonderful renderings bring the story of Lady Liberty to life. Antonio's personal story of his family's immigration to America resonates in his images. Together Dim and Masi have given homage to Lady Liberty and reminded us of the symbol for which she stands."

—Trudy S. Hays, Executive Director, Scottsdale Artists' School

"In this entertaining history of Lady Liberty, author Joan Marans Dim provides a sensitive and insightful tale that includes the passage of millions of aspiring immigrants who—in many cases—were escaping persecution and wishing for a better life as they sailed past the statue's lamp of hope. The prose is wonderfully complemented by the soul-searching images of artist Antonio Masi. A must-read for everyone!"

—David Copeland, actor and director

Lady Liberty

NEW YORK MASTERPIECES, REVEALED

Gotham's treasures—its parks, subways, bridges, tunnels, monuments, skyscrapers, and religious institutions—are the steel, stone, and grit in the lives of city dwellers who mostly rush in, across, around, and through them, rarely pausing to reflect on their history, significance, engineering wizardry, and place in the modern city. Dim and Masi reveal these masterpieces in new ways by blending magnificent art and unvarnished history.

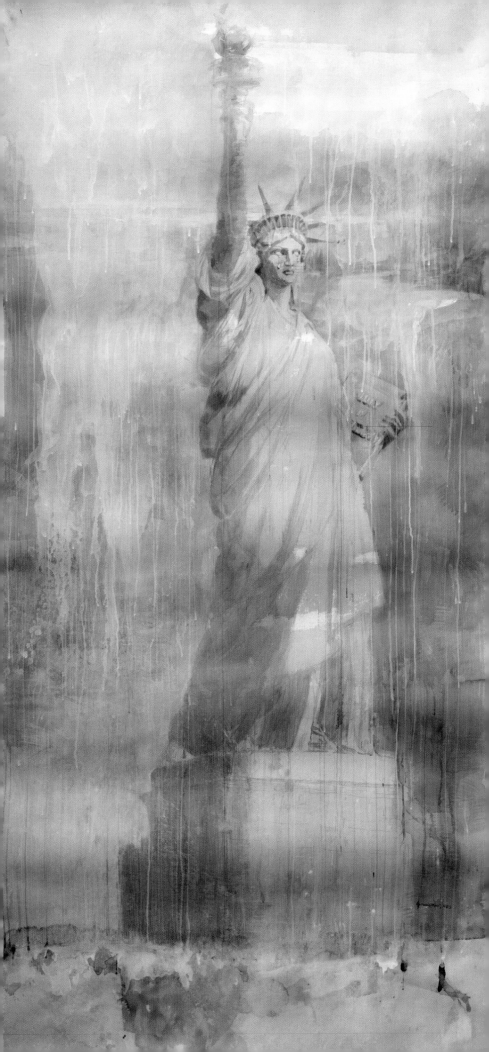

LADY LIBERTY

An Illustrated History of America's Most Storied Woman

Essays by **Joan Marans Dim**

Paintings by **Antonio Masi**

Empire State Editions, an imprint of Fordham University Press

New York 2019

to Johanna Ida Dim Rosman,

—my gifted and inspiring daughter

to Victoria Masi Pryor, Alexandria Masi Keleher, and Paul Masi

—my gifted and inspiring children

Frontispiece: *Mother of Exiles* (82″ × 44.5″)

Fordham University Press has no responsibility for the persistence or accuracy of URLs for external or third-party Internet websites referred to in this publication and does not guarantee that any content on such websites is, or will remain, accurate or appropriate.

Fordham University Press also publishes its books in a variety of electronic formats. Some content that appears in print may not be available in electronic books.

Visit us online at www.fordhampress.com/empire-state-editions.

Library of Congress Cataloging-in-Publication Data available online at https://catalog.loc.gov.

Printed in the United States of America

21 20 19 5 4 3 2 1

First edition

O, let my land be a land where Liberty
Is crowned with no false patriotic wreath,
But opportunity is real, and life is free,
Equality is in the air we breathe.

—A fragment from *Let America Be America Again*
Langston Hughes, 1936

Contents

Foreword by Joseph Berger **ix**

Introduction **1**

1 Illumination **9**

2 Ambition **19**

3 Realization **31**

4 Poetry **43**

5 Immigration **51**

6 Portal **65**

7 Promises **77**

Acknowledgments **85**

Selected Bibliography **87**

Index **89**

Foreword

For the one-hundredth anniversary of the unveiling of the Statue of Liberty in New York harbor in 1986, the *New York Times* asked me to interview a number of celebrities, most of them immigrants, about their reactions to seeing the statue for the first time.

The West Indian writer Derek Walcott said he was moved by gazing at a female goddess rather than "a heroic manly figure." There's "something tender about her," he told me, and "I think at the heart of the idea of American democracy there is something tender." The sculptor Louise Nevelson said she was "overwhelmed—the water and the sky and this wonderful oversized thing. It looked like she reached heaven."

A few days after writing the article I visited my parents, refugees from the Holocaust who had arrived in New York in 1950 after spending five years in displaced-persons camps in a Germany occupied by the Allies. I asked my father what his thoughts were in March 1950 when our merchant-marine ship sailed past the statue as we headed for a West Side of Manhattan pier. Did he feel deliverance? Gratitude? Redemption?

"Who could think about such things?" he snapped, his tearful eyes betraying the depth of his emotions. "I had two little boys I had to feed. I had to make a living."

Think of what the statue must have meant to the immigrants coming over in the 1880s or 1890s or early 1900s. This was a time when skyscrapers did not dominate the Lower Manhattan skyline, and a 305-foot weathered green copper goddess would have stood out like the mirage of a palm

tree to parched nomads in the deep Sahara. Moreover, these immigrants were leaving deeply prejudiced, feudal, or impoverished places where words like *liberty*, *freedom*, and *opportunity* were hollow phantasms. And yet glimpsing the statue may have produced only a fleeting lilt. These immigrants knew it would be hard in the new land. They did not speak English, had meager skills, perhaps no relatives able to help, and the distrust of the longer-rooted Americans was palpable. They had to get on with it on their own.

The reactions to encountering the statue, in other words, were complicated, often counter-intuitive and contradictory. And what is wonderful about the book you are about to read is that Joan Marans Dim, a granddaughter of immigrants, vividly and unflinchingly captures the colorful story of Lady Liberty's birth, life, and impact with all the ambiguities, all the sometimes uplifting, sometimes disheartening twists. And the illustrations by Antonio Masi, an immigrant himself as an eight-year-old, enhance the story with impressionistic paintings that evoke both the haunting splendor of the statue and the fulfillment of its promise for so many embattled immigrants and how far the United States must still go to realize its ideals—as is stunningly apparent in our federal government's current hostility to immigrants.

I learned a lot in *Lady Liberty*.

While we take for granted that the statue is a beacon of freedom and economic promise for arriving immigrants, I never understood that it did not fully inhabit that role until Emma Lazarus's poem, with its poignant appeal "Give me your tired, your poor, your wretched refuse yearning to breathe free" was inscribed on a plaque and posted on its pedestal in 1903. And that plaque was the result of a campaign not by another immigrant but by a high-society matron, Georgina Schuyler, a long-rooted direct descendant of Alexander Hamilton.

The tale of how the statue was conceived and constructed is also full of surprises. Many Americans know that the statue was created as a gift to the United States to mark the anniversaries of the Declaration of Independence and the American victory in the Revolutionary War. But the designer, Frédéric Auguste Bartholdi, sketched the initial design not for a statue to be placed in a U.S. harbor but as a lighthouse for the recently completed Suez Canal. It too was of a woman holding a torch, but it was rejected by the canal authorities.

And what made the final statue light enough to ship from France yet sturdy enough to withstand millions of visitors was a thin copper skin (less than a quarter of an inch thick) and a core armature engineered by Alexandre-Gustave Eiffel—yes, the very architect of another icon, the Eiffel Tower, built for a world's fair.

Throw in a campaign by the American newspaper baron Joseph Pulitzer and you have a marvelous saga of how a vision of a sculpture of improbably colossal scale was realized on a small island off Manhattan.

But Joan Dim does not stop with the story of the statue. She takes us on a jaunt through the history of immigration and the shifting attitudes of Americans toward the newcomers, no matter how much they cherish Lady Liberty in theory. Indeed, we live in a period when our president can demand the building of a colossal wall along the entire border with Mexico to keep out immigrants and can order thousands of

children to be separated from parents who cross that border, without adequate plans to eventually reunite the families.

But there have been times when immigrants were taken in—if not welcomed with open arms—because a developing nation building railroad, automobiles, highways, bridges, and subways needed the strong backs and outsized ambitions of people from abroad who were seeking a better life. That they also got the American songbooks of Irving Berlin, George Gershwin, and Rodgers and Hart; cures for diseases like Jonas Salk's polio vaccine; and the atomic energy created through the theories of Enrico Fermi—bonuses they did not foresee but were glad to have.

The Statue of Liberty speaks to those benevolent interludes in American history, and its enduring presence in the harbor signifies an understanding by most Americans that immigrants come here largely because they're in trouble and need relief. True, America will in twenty or thirty years no longer have a majority of people of European heritage. But Lady Liberty's torch was never designed to shine only for them.

Joseph Berger
The New York Times

Introduction

I arrived—thank God!

—Anonymous immigrant

The voyage was nearly unendurable for nineteenth-century refugees and immigrants traveling to America in steerage. Trapped in a passenger ship's stinking bowels for weeks, suffering the North Atlantic's wind-whipped weather, often seasick, and barely sustained on a diet of often watery soups, these future Americans were robbed of privacy, dignity—truly, any decent comforts.

What courage it must have taken to join such a cavalcade!

Yet a dream sustained them.

Simply put, the dream of a better life. Where they were going to had to be better than where they were coming from. And, even in this new and chaotic twenty-first century, we see that today's refugees and immigrants are often not so different from their nineteenth- and twentieth-century brethren and those who preceded them. All of them want to worship freely, work for a fair wage, live peacefully, raise a family, have adequate food and shelter, and be liberated from despotic rule.

There's Something about Grandma

Such was the story as I remember it now about my maternal grandmother.

When she was a young girl, perhaps eight years old, Grandma Ida and her family fled from the Pale of Settlement, a western section of Russia that came into being in the late 1700s. The Pale was a place where Jews were legally allowed to live. But theirs was not much of a life.

The tribulations of Jewish life in the Pale

of Settlement were recorded in the writings of Yiddish author Sholom Aleichem, whose novel *Tevye der Milchiger* (Tevye the Milkman) was a narration of Teyve's life in the fictional *shtetl* of Anatevka. Eventually the play and film *Fiddler on the Roof* followed.

In the Pale's *shtetls*, Jews lived in wretched poverty and in dreadful fear of *pogroms*—vicious campaigns of anti-Jewish violence by non-Jewish street mobs. *Shtetl* Jews had few rights and no opportunities to improve their lives. Because of the harsh conditions in the Pale, some 2 million Jews emigrated, mainly to America, between 1881 and 1914.

Sometime in the late nineteenth century my grandmother's family—a part of this great migration—*understood* that they must escape. The country of their most extravagant dreams was always America, the place my grandmother would one day, more than a half-century later, describe as the "golden land."

The family arrived in America with little money; they did not speak English and had no marketable skills or attributes other than a raw determination to make a better life than the one they had left.

Grandma Ida married a tailor, and together during the early 1900s they opened a modest dry cleaning and tailor shop in New York City. As they grew prosperous, they decided to move to a more upscale neighborhood where they opened a "Fancy Parisian Dry Cleaners."

My grandparents were a team, but it was my grandmother who was, according to family lore, the brains behind the team. The notion of running an emporium specializing in "fancy Parisian dry cleaning" was Grandma Ida's brainstorm. She discovered her entrepreneurial self and in the process defined herself as a fancy Parisian dry cleaner. No matter that she probably had no idea where Paris was, nor any intention of finding out. No matter that there was no such unique process as fancy Parisian dry cleaning—except as a figment of her rich imagination. She divined this idea and was now ready to cater to a wealthy clientele, who in her view clearly required something more impressive than two Russian Jewish immigrants tending their opulent garments. A fancy Parisian Dry Cleaning truck, manned by a driver in a crisp gray uniform, busily crisscrossed the neighborhood picking up and delivering garments. As time went by, they grew even more prosperous and lived in a ten-room apartment in a luxury building across the street from their store. My grandmother indulged herself and bought sapphire bracelets, diamond earrings, and other jewelry that would later be passed down to me.

She was a small woman, and she seemed ancient. Yet while her body was bent, her eyes were aware of everything and darted from object to object, rarely alighting anywhere for long. She sometimes would run her gnarled hand affectionately across the top of my head as if she had just discovered some small detail about me—perhaps that I had grown slightly—that pleased her.

Today, except for the facts supplied by my mother, she is almost a faded memory except for one brief, magical day with her that I still vividly recall. It was a scorcher at Rockaway Beach during the summer of my sixth year, and on this day Grandma Ida was my babysitter. I had her all to myself. She packed us a picnic basket of egg salad sandwiches on Wonder Bread, dill pickles, a brown bag full of brilliantly red cherry

tomatoes, and a thermos of Kool-Aid, and we headed for the beach. We spread our blanket out on the hot sand, and she slathered me with suntan lotion.

To entertain us while we ate, she told me a "special" story of how she came here. She began with her voyage on a passenger ship from Russia to America. She was a little girl, not much older than I, she said. She was with her parents and sisters. They never served egg salad sandwiches or dill pickles in steerage, she added. No Kool-Aid or cherry tomatoes, either.

"What's steerage?" I asked.

"It is the cheapest way to travel on a boat."

Then, she told me how her mother would sometimes mix a few grains of sugar with warm water for a special nightly treat for her and her sisters.

"It was so delicious, I can still taste it," she said, closing her eyes and smacking her lips.

"I want some," I demanded.

She laughed.

"It's not so different from Kool-Aid."

She said the entire trip was spent in the bottom of the ship. She really missed the sunlight and thought the trip would never end.

Then she described how the family sometimes slept huddled together under one rag blanket on a bed that was just a wooden board. And there were many people in bunks sleeping around them, too, she said. It was cold and the boat rocked back and forth and some people got sick, but it didn't matter because it was a thrilling adventure. She was coming to America, the "*Goldine Madina*"—the golden land.

"Real gold?" I asked.

"In a way," she answered.

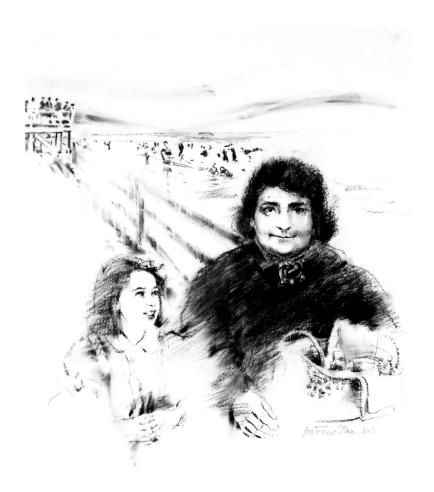

Joanie and Grandma Ida (34″ × 26″)

Then she told me about the great lady with a torch upraised in one hand and a book in the other.

"Only when you see her will you know that you have *really* arrived in America," she told me.

"Did you see her? Did you see her?" I cried, enthralled.

She just smiled, and I knew the answer.

We stayed on the beach until the sun slipped below the horizon. Nobody but the seagulls and us were left. Then we slowly made our way back, climbing the steps to the boardwalk and walking down the ramp to Beach 47th Street to our bungalow.

Just before we reached the bungalow, she stopped and gave me a hug.

"Joanie," she murmured in my ear, "we had a good time. Yes? Someday I promise I

will take you to see that great lady with the upraised torch in her hand."

It was the best day I ever had with my grandmother.

As I think back upon that day, I would so like to hear more stories and ask her many more questions. What happened to her mother and father? What were those first few days, months, and years like for the family in America? What could she tell me about the Old Country? How did she meet my grandfather? Was it an arranged marriage? Did she love him? What was it like to be a working mother? How did she manage to raise two children while working without help? And what did the Statue of Liberty mean to her, exactly? So much to discover and so little time in which to do it.

Grandma Ida died less than a year after our magical day at the beach. She was in her early sixties. By today's standards she was relatively young, but years of grinding work in the cleaning store had taken their toll.

When my mother told me the news, I was sad and cried at her funeral. Still, I was only a child and did not grasp the full significance of her death. What if she had lived another ten, twenty, even twenty-five years longer? What a gift that would have been to me—and to her. But the chance to learn personally *all* about where she came from died with her. And to fully grasp the full meaning of that first meeting with that great lady with the upraised torch. To hear her appreciation of American values and opportunities. Unfortunately, the nuances of her life would eternally escape me. So would the sheer pleasure of her company as I grew up. Nor would her religious traditions or her personal experiences of being a daughter, sister, wife, mother, grandmother, and working woman, free at last, from the

shackles of shtetl life be shared. All this—and more—would be lost.

Yet I would not fully appreciate the immensity of my loss and the potential for what might have been until I completed this book.

The Origins of an Artist

Artist Antonio Masi's path to America begins with his grandfather Francesco Masi, who left the hills of Sicily with his wife and five children in the early twentieth century to haul steel on the rising Queensboro Bridge (now the Ed Koch Queensboro Bridge) in New York City. It was a dangerous job, and by the opening of the bridge in 1909, some fifty laborers had died.

Grandpa Francesco, one of the lucky ones, had a felicitous experience toiling on the Queensboro Bridge; he emerged whole and healthy from his labors and optimistic about America's future. To Grandpa Francesco, America and its greatest city were a wonder of hustle and bustle. Grandpa Francesco also understood that America was a place of great opportunities and freedoms. Here, a man with a strong back could earn a living in many ways. He also saw that the city's infrastructure in the early twentieth century was yet to be built and that multitudes of laborers would be needed. Already a newfangled train—a subway—ran from City Hall to 145th Street and Broadway. And then there were those large-scale, long-span bridges—the Brooklyn Bridge, opened in 1883, the Williamsburg Bridge in 1903, and the soon to be opened Manhattan Bridge in 1909.

What a marvel was New York! What a marvel was America! What a place to live and work!

War and Legacy

Yet the winds of a world war would intervene. In 1914, the assassination of Archduke Franz Ferdinand, heir presumptive to the Austro-Hungarian throne, triggered what became known as World War I, and Grandpa Francesco decided to move his wife and children back to Italy, where his large extended family resided.

But one of his children, Joseph—the future father of Antonio—decided instead to enlist in the U.S. Army rather than return to Italy. In 1917, Joseph was shipped to France, where he served as an Army veterinarian. As a consequence of his service, Joseph was granted American citizenship. Another benefit of Joseph's U.S. Army service was that all of Joseph's *future* children also would be granted American citizenship.

Following his Army discharge, Joseph returned to his family in Italy, where he married and raised a family. Nevertheless, the possibility of a life in America never left his thoughts.

Nor did it ever leave Grandpa Francesco's thoughts; he never ceased telling and retelling his tales, and by his death in 1941, his stories of America had attained an almost mythic status, especially in the Sicily branch of the Masi family, who would struggle to survive World War II.

Particularly engaged with Grandpa Francesco's stories was young Antonio, who lived on a farm with his parents and seven siblings in Mezzojuso, a country town tucked

Old Country
(30″ × 40″)

into the hilly province of Palermo in Sicily. On the farm, the Masi family grew wheat, fruits, and vegetables; raised pigs, chickens, and horses; and depended upon their crops and animals to sustain them all year. There were no supermarkets; in fact, there were no stores to buy anything. Everything the family ate, they grew. Everything they wore, Antonio's mother, Carmela, made. The family also had a small, secluded house with a barn on the fringe of Mezzojuso. The house's most important function was as a safe house—the place the Masi brood escaped to during bombing raids and where they spent nights huddled in the barn listening to nearby exploding bombs.

"My recollections of living in Italy during World War II are all bad," Antonio recalls. "I have no good memories. None."

One night, Mussolini's marauding soldiers invaded the farm and stole all the family's food and grain. With ten mouths to feed, the family lived in constant fear and hunger. They survived, but just barely. By the end of the war, Italy was in ruins and the government had confiscated almost everything they owned. Moreover, there was no work, and no promise of work except possibly farming. And what about the children? Joseph did not want his children to be farmers. He wanted a better life for them. Two slender threads of hope had carried the Masi family through their ordeal: One was Grandpa Francesco's stories of America, and second was the fact that Joseph and all eight of his children were American citizens as result of his U.S. Army service. Thus, the possibility . . . the almost intoxicating possibility . . . of emigrating to America loomed larger every day.

Americans, fantastically, had running water and electric lights in their homes, and America had stores, all kinds of stores, including food and clothing stores. That meant Carmela would never again have to

bake bread, wring a chicken's neck, sew the family garments, or milk a cow—in America, amazingly, milk was bottled and sold. Yet Carmela was uncertain. She didn't want to leave a beloved sister behind. But Joseph and his brood were enthusiastic . . . if just a tad scared.

Coming to America

On a wintry day in December 1947, the Masi family, having made the bold decision, packed their meager belongings and traveled to Palermo to board a passenger ship bound for New York City. The trip to America was uncomfortable, but better than Grandma Ida's experience. The family spent much of the voyage in one smallish room that they shared with some fifty other immigrants. In this room, people lived shoulder to shoulder. The room was dimly lit, cold, and damp. Wooden bunk beds lined the walls. Meals were served in a dining room outfitted with wooden benches and tables. To Antonio, the food was strange. On one occasion, he mistook frankfurters for Italian sausages, over-ate, and was sick for days.

The voyage, lasting twelve to thirteen days across the stormy North Atlantic, rocked the ship, and the family, along with almost all the other passengers, suffered seasickness. The only respite, one not afforded nineteenth-century immigrants, was that steerage passengers were allowed to visit the top deck of the ship. Antonio remembers enjoying the luxury of the fresh sea air and watching monster waves crash into the ship's bow.

Time crawled, until at last the ship sailed into New York harbor. Even though the hour was late, every steerage passenger was on deck. Downtown Manhattan slept; still, the outlines of the buildings were apparent. No matter. A mixture of joy and relief swept through the crowd. Then, in the distance, the Statue of Liberty, her torch held high, appeared.

"*La vedo! La vedo!*" "I see her. I see her," the crowd roared in Italian.

Passengers rushed to the port side of the ship to get the best view of the Lady.

"It is hard to put the emotion of that moment into words," Antonio reflects, "but it has stayed with me my entire life."

Seeing the Statue of Liberty certified to the Masi family—and likely all the refugees and immigrants on the ship—that finally they'd arrived safely in America. For all, the journey to America had been long, arduous, and replete with wartime perils.

Because Joseph and his children were considered American citizens, the entire family, including Carmela—who would later become a citizen—was not forced to negotiate Ellis Island. Instead, they disembarked and swiftly moved through Customs.

Now, all their hopes and dreams for a decent life coalesced.

The Old World was behind them.

And the New World beckoned.

New York City, circa 1947

For the Masi brood, New York City was heaven on Earth.

They lived in a railroad flat, an apartment with rooms arranged in a line, in New York's Yorkville section, on 74th Street at Second Avenue. The flat had five rooms, a kitchen with a tub in it, a kerosene stove for heat, a stove for cooking, and one small bathroom. Antonio and two younger brothers slept in one room, three older brothers stayed in the living/bedroom, an older sister had a

American Dream
(30″ × 40″)

tiny room with a light well, and Joseph and Carmela and their youngest daughter shared another tiny room.

Joseph worked as a janitor in office buildings in New York. And the older children found jobs in factories, a butcher shop, and a dry cleaning store. The younger ones went to school. Each child delivered his or her paycheck to Carmela, who sagely controlled the money.

"My mother made sure no one lacked for anything and that the family was safe and healthy," recalls Antonio. "She also saved every penny she could, and within eight years, the family was able to purchase a home in Queens, New York. My mother—she was a force."

Carmela never saw her beloved sister again. Still, she adored America. She studied, learned English, became a citizen, and—like her family—delighted in being an American. If anyone spoke Italian in the house, Antonio remembers, she'd firmly instruct them: "You are in America! You are an American! Speak English!"

Blessings

What would Grandma Ida and Grandpa Francesco say today about the lives of their children and grandchildren and great grandchildren, ad finitum?

This is a question we can't exactly answer. But we feel certain they are smiling.

Illumination

1

We may have all come on different ships, but we're in the same boat now.

—Dr. Martin Luther King Jr.

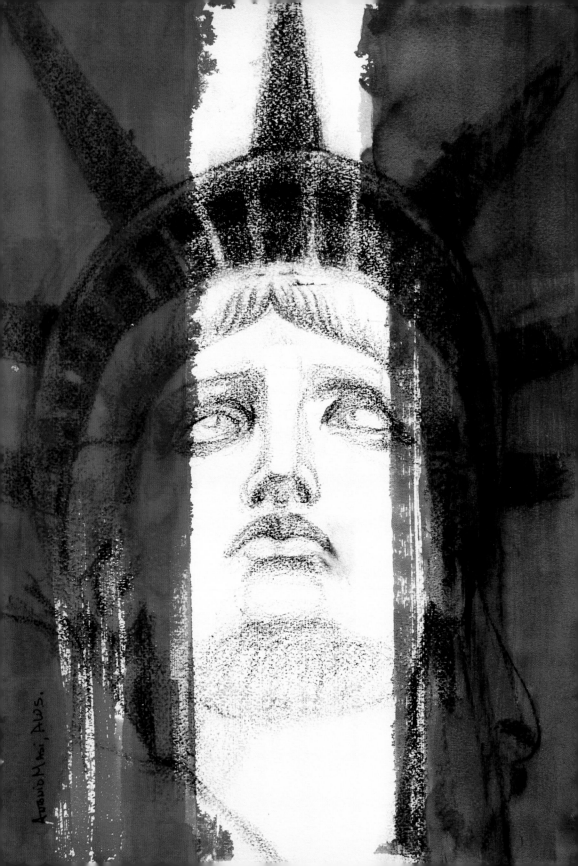

October 28, 1886. 'Twas cold and stormy in New York City. No matter. A dream of decades was finally realized, a work of art had been created, and a sense of lofty import and festivity spread across the metropolis as thousands of visitors and city folk surged through the streets.

This was the day of the Statue of Liberty's parade, dedication, and unveiling.

And, it seemed, everyone wanted to see it.

The Gift

The Statue of Liberty, originally named The Statue of Liberty Enlightening the World, was a gift from the citizens of France to the citizens of America and honored two of history's stellar achievements, the creation of the Declaration of Independence in 1776 and the successful conclusion to the American War of Independence in 1783.

The signing of the Declaration of Independence begat eight grueling years of conflict during which thirteen colonies joined in a loose union to raise a small army to fight, at the time, the most powerful nation in the world. As the Declaration was signed, circulated, and preserved, each signer stood convicted of high treason by the English Crown.

"*I know not what others may choose but, as for me, give me liberty or give me death*," railed Patrick Henry, a Founding Father, a governor of Virginia, and a champion of the American Revolution.

The truth is that few in Europe at the time held much hope for the band of passionate rebels. Despite their daring language, set on parchment, and faith in the rightness of their cause, victory in a war with England seemed improbable. Yet despite the long odds, the Americans beat the British. In the war's

decisive battle, General George Washington, assisted by some 5,000 French troops and with his most trusted aide-de-camp, France's Marquis de Lafayette, accepted Lieutenant General Charles Cornwallis's surrender at Yorktown on October 19, 1781. Legend has it that the British military band marked the moment by playing the popular ditty "The World Turned Upside Down."

America's successful quest for independence also roused the French on their own quest for independence. The French Revolution, beginning in 1789 and ending in the late 1790s, razed France's political landscape and uprooted ubiquitous institutions such as the absolute monarchy and the feudal system. And like the American Revolution before it, the French Revolution was greatly influenced by the concepts of self-government, unalienable rights, and the power inherent in the will of the people.

Thus, the bonds of respect and friendship between America and France, formed during two bloody revolutions, were historic and genuine, and from these events emerged, in the mid–nineteenth century, a French coterie—people of talent and import—who championed creating and delivering to Americans the gift of a colossus, and integral to the giving was the notion that the gift also be reciprocal, that it should symbolically represent the unity and friendship between the two nations.

Let the Revelry Begin

The dedication and unveiling of the colossus commenced on the morning of October 28, 1886, with a parade beginning on Fifth Avenue and 57th Street and running some four miles to the Battery, Manhattan's southern tip. Most businesses were closed as tens of

thousands surged through the streets. Music was everywhere, mostly French and American patriotic songs, played by one marching band after another. Marchers included politicians, veterans, policemen, firemen, and students, plus similar luminaries from distant cities. Everyone seemed to carry a flag; some waved the French flag, the blue, white and red Tricolor—representing liberty, equality, and fraternity, the ideals of the French Revolution. Others proudly waved Old Glory.

As the parade passed the New York Stock Exchange, traders, launching a tradition, tossed ticker tape out the windows.

At the Battery, the scene was stirring. The crowd could see the copper figure of Lady Liberty rising through the rain and clouds on Bedloe's Island, sitting 1.58 miles from the shore in upper New York bay. (Bedloe's Island was renamed Liberty Island in 1956.) A Tricolor shrouded her face; her right hand lifted high held the torch of Liberty.

Dedication and Unveiling

Lady Liberty's dedication ceremony began when President Grover Cleveland and a mostly male entourage boarded a yacht bound for Bedloe's Island. A flotilla of tugs, ships, ferryboats, and pleasure craft followed the president's yacht and then docked around the island, hoping to get a close-up view of the proceedings and, perhaps, through the din hear the speechmaking.

A lengthy program of music, prayers, and speeches was planned, including one from Ferdinand de Lesseps, a key figure in the development of the Suez Canal and a staunch supporter of the Statue of Liberty. Frédéric Auguste Bartholdi, the French sculptor and designer of the statue, perched in the statue's crown. Bartholdi's task was to tug

a rope that would lift the Tricolor from Lady Liberty's face when the president's speech ended. Perhaps because of the tumult of the crowd and surrounding boats, Bartholdi lifted the Tricolor prematurely in the midst of a speech by William Evarts, a U.S. senator from New York. Cheers erupted as the Lady's face was revealed; the senator's speech was lost in the hubbub.

Still, the show must go on.

Finally, it was President Cleveland's turn to speechify.

The president's most memorable line was a heartfelt promise.

"We will not forget that Liberty has made here her home," he said, "nor shall her chosen altar be neglected."

When the president, finally, accepted the statue from France, the crowd—this time on cue—roared its approval as gun salvos boomed, foghorns blared, and the flotilla of ships set off alarms and released plumes of smoke.

The grim weather didn't seem to dampen the event.

The new Anadyomene was Liberty rising in the sea, gushed the *New York Times*.

Yet, not Everybody Was Pleased

Members of the Woman Suffrage Association were infuriated that all women—except for two—were banned from attending the Bedloe's Island dedication.

After all, the statue was a *woman*!

After all, her name was *Liberty*!

The wife of Bartholdi and the granddaughter of Ferdinand de Lesseps were the privileged female attendees. Organizers of the event lamely explained that the ban was necessary because women in dresses were

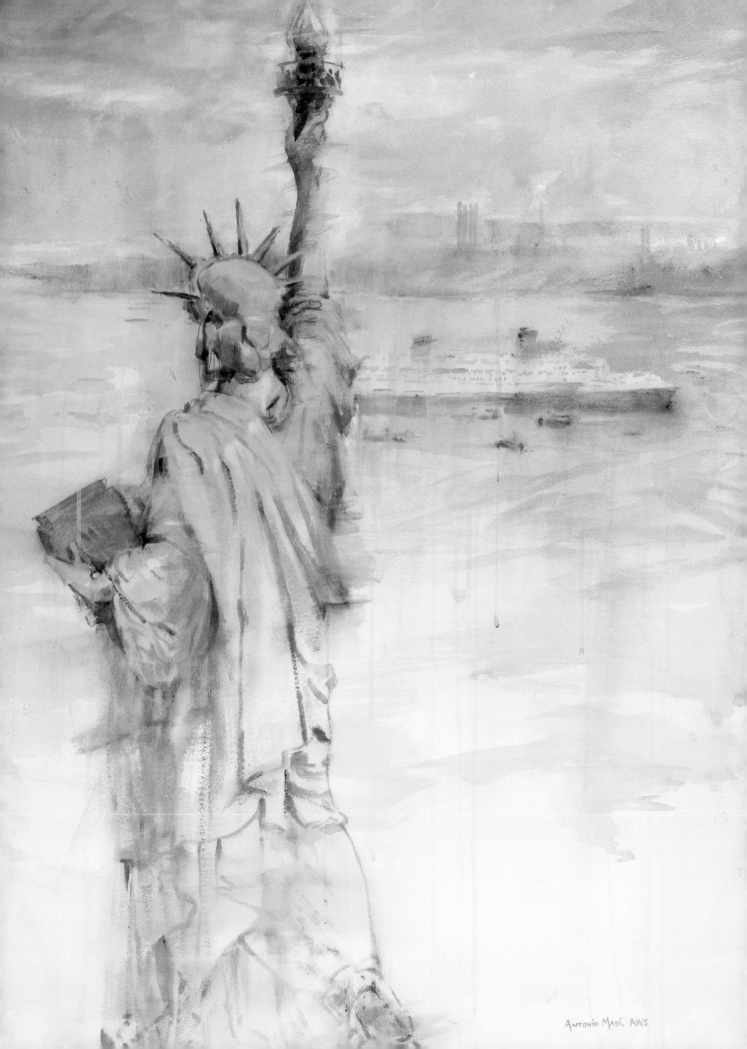

Antonio Masi, AWS

in danger of being crushed by the large crowds. In defiance of the ban, the Suffragettes rowed out to Bedloe's Island, joined the flotilla surrounding the Island, and delivered firebrand speeches denouncing America's injustices to women and demanding women have the "liberty" to cast votes. Their pleas were reportedly drowned out by the tumult surrounding them.

Meanwhile in Ohio, the *Cleveland Gazette*, an African-American newspaper, published the following invective:

> Shove the Bartholdi statue, torch and all, into the ocean until the "liberty" of this country is such as to make it possible for an inoffensive and industrious colored man to earn a respectable living for himself and family, without being ku kluxed, perhaps murdered, his daughter and wife outraged, and his property destroyed.

In retrospect, perhaps we shouldn't be surprised at the *Cleveland Gazette*'s sentiments; its boldness in the context of the times, however, surprises. Little more than two decades earlier, America's bloodiest war, pitting the Union against the Confederacy, had ended at the Appomattox Court House in Virginia, when Confederate General Robert E. Lee surrendered his Army of Northern Virginia to Union General Ulysses S. Grant. Some 620,000 died in the conflict. Many more were injured. And only five days after Lee's surrender, tragedy again engulfed the nation when John Wilkes Booth assassinated President Abraham Lincoln.

Yet, amazingly, the calamities of war and assassination, the tragedies of slavery, and the government's disastrous Reconstruction policies imposed upon a vanquished Confederacy did not dash the adolescent country's hopes. Like a phoenix rising from the ashes, America would meet the coming Industrial Revolution.

The Industrial Revolution

Central to America in the nineteenth century was the Industrial Revolution, which sparked major changes in transportation, manufacturing, and communications and ultimately transformed the daily lives of all Americans. Beginning in force after the Civil War, the Industrial Revolution continued for almost a century, as the pace of production of goods quickened and moved from home businesses—where products were generally crafted by hand—to machine production in factories.

An early sign of the coming revolution was the opening in 1825 of the Erie Canal, an engineering marvel running 363 miles that opened the West to settlement and commerce. The canal's instant success quickly demonstrated that transporting people and commerce would be essential to the nation's expansion. That meant, at least to start, building roads, canals, and railroads.

In 1830, President Andrew Jackson authorized government projects costing $96 million (approximately $2.5 billion in today's dollars) for roads, canals, and railroads. The following year, the first train in the United States powered by a steam engine made its initial run. By 1869, the modern age of transportation became official in Promontory, Utah, when a golden spike connected the East with the West, under the banners of the Union Pacific and Central Pacific railroads.

At this juncture in America's history, it was already clear that it would be immigrants who would build the nation . . . millions and millions of immigrants.

Seventeen years after the so-called birth of the modern age of transportation, the Statue of Liberty was dedicated on Bedloe's Island, and, as time moved on, the Lady would be inexorably linked to America's immigrant saga.

One Immigrant's Tale

John Augustus Roebling was a model for the preferred American immigrant. He was male, white, and highly educated with important engineering skills. He also was clever, ambitious, and extremely hardworking. His life is the fabric from which American dreams are spun, and for this reason his journey weaves throughout this tale.

Roebling designed the Brooklyn Bridge and was the pathfinder of modern bridge building. His pioneering introduction of steel cabling made the Brooklyn Bridge, at its opening, the longest and strongest suspension bridge ever. Unbeknownst to many is that Roebling also was a major American industrialist, the creator of the wire-rope industry, a business that supported a parade of progress.

Roebling arrived in 1831, just as the nation began to be aware of its power, resources, and vastness. Only twenty-five years old, Roebling traveled from Mühlhausen, Germany, with a group of farmers and settled in Saxonburg in western Pennsylvania. Although educated at the Royal Polytechnic Institute in Berlin as a civil engineer, Roebling temporarily put aside his career as an engineer to be a pioneer farmer. He stayed abreast of bridge building by reading engineering journals. In 1836, he married Johanna Hertig, the eldest daughter of a Saxonburg colonist who had emigrated from Mühlhausen two years earlier. They had nine children. In a tip of the hat to Roebling's new homeland, he named his first child Washington Augustus Roebling, after America's first president.

The late David Steinman, a noted bridge builder, writes in his history of the Roeblings, *The Builders of the Bridge*, that "The time was right, when John Roebling arrived to build his life in the stimulating and receptive atmosphere of a young and rapidly developing country." Steinman adds that Roebling

John Augustus Roebling (40″ × 26″)

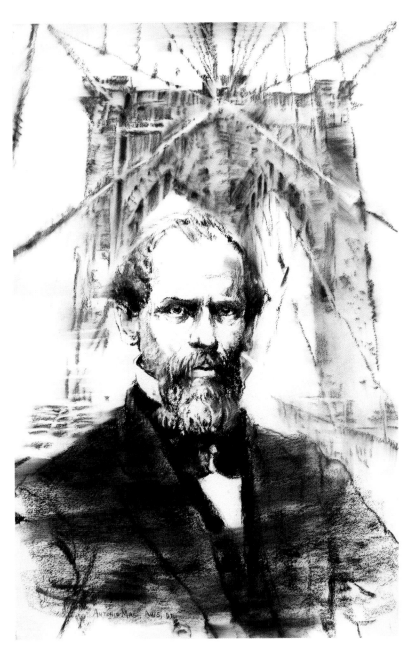

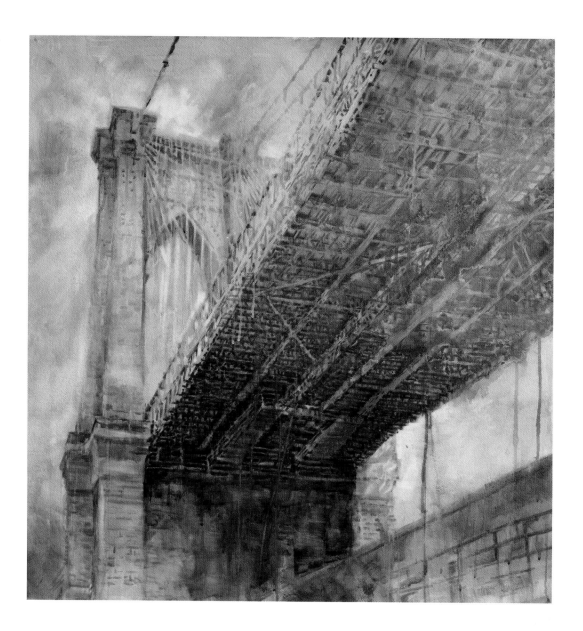

was "ready and eager to fit into the picture and to make his contribution."

In a letter to a friend in Mühlhausen, Roebling captures the marvels of the new land:

Whence has the multitude of splendid steamboats, mailboats, highways, railways, steam cars, canals, and stages sprung up in so short a time? In part, of course, this is explained by the natural and fortunate position of the country with its manifold resources; but it is principally the result of unrestricted enterprise and the concerted

action of an enlightened, self-governing people.

Roebling's admiration for his new home-land was directly linked to its freedoms and opportunities. At the time of Roebling's departure, upset plagued Europe, and Germany's autocratic rule had stifled his engineering ambitions. So he fled, leaving his family and many friends behind.

America was Roebling's ticket to a free and productive life.

His masterpiece of steel and stone opened May 24, 1883, little more than fifty

years after his arrival in America and three years prior to the Statue of Liberty's arrival. Likely the only thing he truly missed was the Statue of Liberty welcoming him in New York harbor.

Help Wanted

By 1901, the first automobile went on sale. By 1927, Henry Ford had rolled off his assembly line more than 18 million Model Ts. America boomed! America required people. Millions of them, as it never had before. Technically and scientifically trained professionals—educators, inventors, architects, engineers, scientists, physicians, lawyers, politicians, entrepreneurs—were necessary for educating the populace, creating the nation's great structures, and providing a bedrock of stability. Also needed were laborers with strong backs and brave hearts who would be essential in erecting cities, roads, canals, bridges, tunnels, factories, and railroads. Welders, plumbers, mechanics, machinists, boilermakers, pipe fitters, and others were needed . . . and still others to farm the land and toil in the soon-to-be proliferating mines, mills, and factories. Come one, come all was the nation's mantra.

And still others were needed. The nation, moving at high speed and in multiple directions, also required writers, poets, actors, artists, and playwrights whose work would promote and perpetuate the American saga and its promises of liberty and labor . . . for all.

Such writers, for example, as Mark Twain and Louisa May Alcott, both born early in the nineteenth century, employed wit and wisdom to explain and, at times, expose the shifting winds of American values and culture and forced the populace to consider

the hard issues of the day, such as class, slavery, and women's rights. Poet and journalist Walt Whitman, born in 1819, wrote *Leaves of Grass*, a landmark in American literature. Whitman's sexual imagery proved controversial, but nevertheless he was influential in moving the adolescent nation into a more open, realistic, and mature realm. Louisa May Alcott was born in 1832. Her popularity has been compared to that of J. K. Rowling. Interestingly, Rowling has compared herself to Jo March, one of Alcott's most engaging heroines in *Little Women*. Jo, trapped by nineteenth-century mores, ached to be more than society allowed. In real life Alcott succeeded beyond her wildest dreams by becoming a self-supporting writing sensation and paving the way for women's rights.

Emma Lazarus

It is impossible, of course, to list all those who sparked the nation during the nineteenth and twentieth centuries. Enough to say that America received an astonishingly rich bounty of new citizens during this era. Yet, one person stands apart on these pages from all others because she was essential to shaping the saga of the Statue of Liberty.

In 1883, Emma Lazarus, thirty-four years old, was a poet with a small, elite band of admirers, including her mentor Ralph Waldo Emerson. She came from a wealthy Jewish family and fit comfortably into New York's high society.

At the time, efforts were underway to fund a pedestal and foundation to support the Statue of Liberty. While the French paid for the statue's construction, America was responsible for funding its pedestal and foundation. Notable writers and authors in New York, eagerly anticipating France's gift

of the Statue of Liberty to America, solicited support from Lazarus. Would she compose, they asked, a sonnet to be sold at auction, alongside the writings of Mark Twain and Walt Whitman? She agreed, although somewhat half-heartedly. She was not a poet accustomed to writing on command. What Emma Lazarus—and everyone else—didn't know at the time she finally agreed to her poetic task was that her sonnet *The New Colossus* would for many define America's vision of liberty.

In fourteen lines, Lazarus spoke directly of the refugee and immigrant plight, their craving for freedom and opportunity while also illuminating America's astonishing beneficence. Today, the last five lines of the sonnet are what most people remember and repeat; still, the entire sonnet is worth reading.

The New Colossus

Not like the brazen giant of Greek fame,
With conquering limbs astride from land
 to land;
Here at our sea-washed, sunset gates shall
 stand
A mighty woman with a torch, whose flame
Is the imprisoned lightning, and her name
Mother of Exiles. From her beacon-hand
Glows world-wide welcome; her mild eyes
 command
The air-bridged harbor that twin cities
 frame.
"Keep, ancient lands, your storied pomp!"
 cries she
With silent lips. "Give me your tired, your
 poor,
Your huddled masses yearning to breathe
 free,
The wretched refuse of your teeming
 shore.

Send these, the homeless, tempest-tost to
 me,
I lift my lamp beside the golden door!"

Illumination

Edward Berenson writes in his book *The Statue of Liberty: A Transatlantic Story*:

Conceived as an altar of liberty, Bartholdi's statue would come to represent Lazarus's "huddled masses yearning to breathe free." You may also remember President Grover Cleveland's solemn promise at the Statue's dedication, ". . . that we not forget that Liberty has made her home here, nor shall her chosen altar be neglected."

Yet even a brief reflection reveals that Liberty's altar has been neglected. Some might even say abandoned. America's beneficence, granted by the Declaration of Independence and the Constitution, opened the doors to refugees and immigrants for a greater period than ever before in history, yet America's beneficence has, in fact, had its limits. The displacement and plundering of native Americans, the stain of American slavery, the inequality of women, biased immigration policies, the internment of Japanese Americans during World War II, and the often harsh, even purposely cruel treatment of refugees and immigrants cannot be ignored.

The truth is that Lazarus's sonnet, though beautifully wrought, sometimes rings hollow.

Yet, despite all this, The Statue of Liberty, stands as a perfection of art, engineering and symbolism.

And this is her unvarnished tale.

Ambition

2

A man's worth is no greater than the worth of his ambitions.

—Marcus Aurelius, *Meditations*

When Frédéric Auguste Bartholdi, the designer of The Statue of Liberty, sailed into New York harbor for the first time on June 21, 1871, his vaulting ambition was to persuade Americans to embrace and support his goddess of Liberty.

Knowing not a soul, he set out on his grand tour of America armed with letters of introduction and the generous sum of $40,000 to cover costs. At once, he experienced the bustle and din of New York City. Then he traveled to Boston, Hartford, Denver, Washington, Philadelphia, Cincinnati, St. Louis, San Francisco, Niagara Falls, and Salt Lake City, to name a handful of destinations. He traveled by train, and from his railroad car he studied America—the farms, the factories, the towns and villages, the proliferating roads and bridges and railroads. He crossed the prairie. He viewed the Rocky Mountains and Sierra Nevadas. By all reports, the nation's vastness and grandeur moved him deeply. He saw a nation on the move, a nation on the up-and-up. And while consumed with his own artistry, the acceptance of it, and need to find financial support, he was heartened by America's vastness because it kindled the fond hope that his colossal dream might actually appeal to Americans.

"Everything is big here, even the *petit pois*," he quipped.

On his quest, he met and talked with such luminaries as Peter Cooper, Horace Greeley, Brigham Young, Henry Wadsworth Longfellow, and President Ulysses S. Grant. He told them all of his colossal Lady. Everyone was polite and friendly—but disappointingly unmoved or noncommittal.

Bartholdi soon realized that it would take more than financing a trip and letters of introduction to win American support for his goddess.

The statue was always meant to be a joint project between the two nations. While the French would raise some $250,000 for the statue, America needed to raise another $250,000 to pay for the pedestal and foundation. The late–nineteenth century's $250,000 amounts to approximately $4 million today. Raising money for the statue's pedestal and foundation would be a huge challenge, despite the persistent appeals from a little-known French sculptor.

So, in the early summer of 1871, as Bartholdi sailed into New York harbor, the Statue of Liberty's future home in America was hardly assured.

Nevertheless, he was game.

Ambition propelled him . . . *colossal* ambition.

Roots

Frédéric Auguste Bartholdi was the son of devout and respected Protestants who had moved from the Rhineland in the early 1800s to Colmar, a small city in France's Alsace region. His father, Jean Charles Bartholdi, a successful civil servant and a prosperous real estate investor, died in 1836, just two years after his son's birth. Bartholdi's mother, Charlotte, sagely managed the family fortune after her husband's death and financed her son's lavish artistic dreams, including the gift of $40,000 for his first trip to America.

Young Frédéric, reportedly a middling student, was educated in Paris. In 1852, he graduated from Lycée Louis-le-Grand and later concentrated on painting and architecture at the École nationale supérieure des beaux-arts.

Charlotte and her son were atypically close. Historians often have speculated

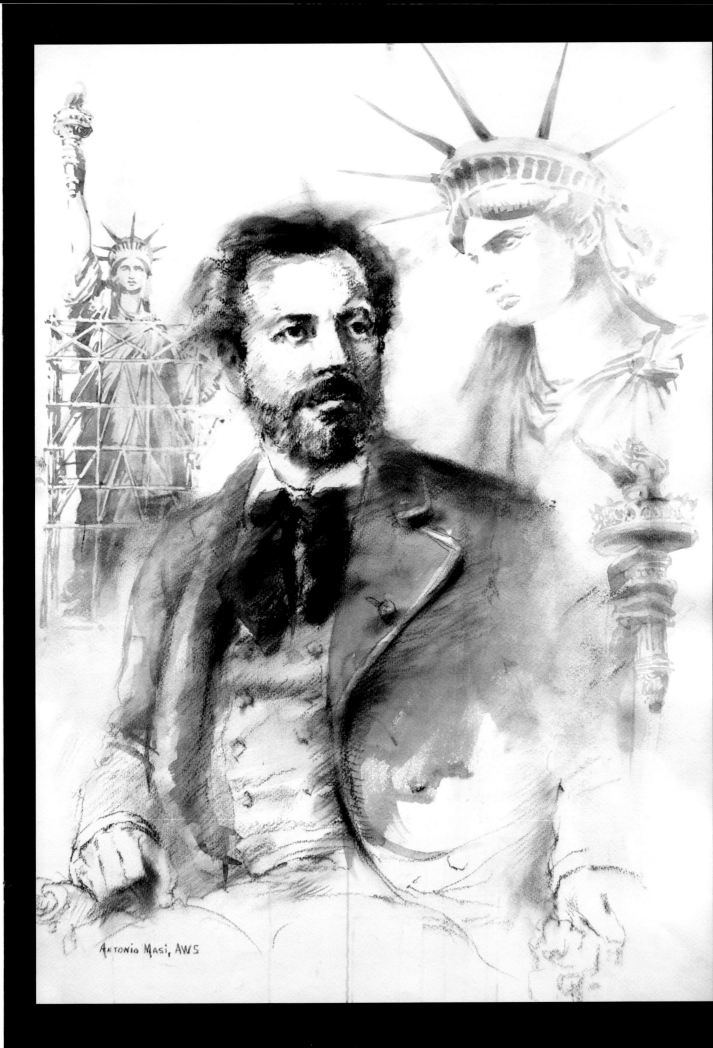

Antonio Masi, AWS

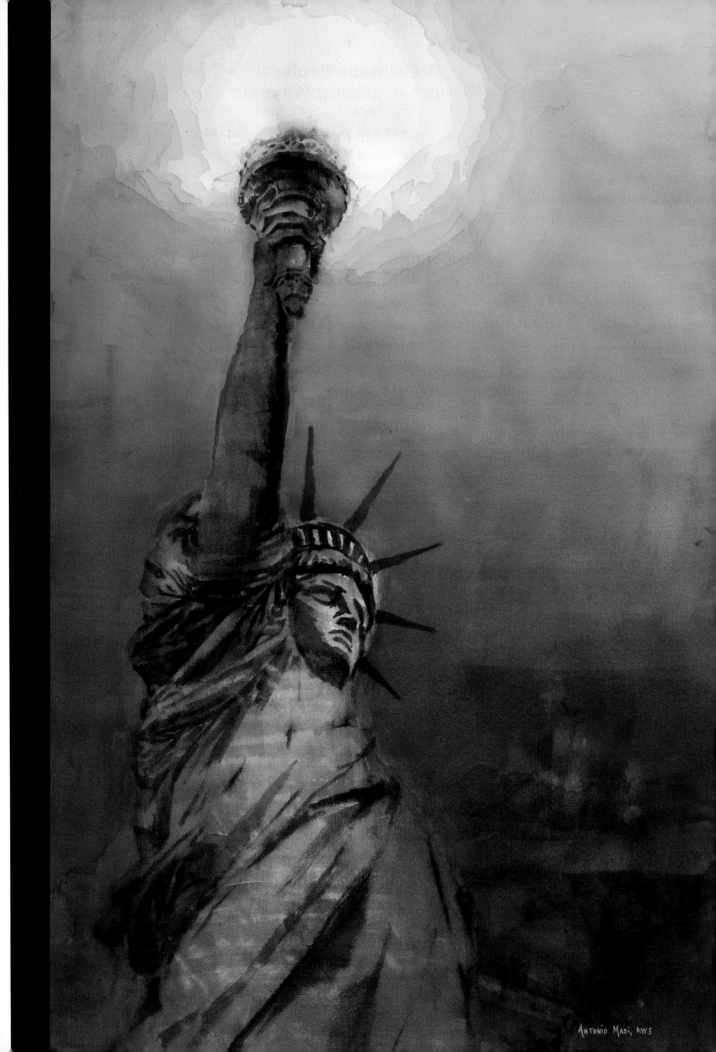

Antonio Masi, AWS

the figure . . . hiding the light under its petticoat not to say under a bushel?

Despite the sculptor's droll denial, overwhelmingly historians agree that the final lighthouse drawings bear a striking resemblance to the Statue of Liberty.

Turning Misfortune into Fortune

The rejection of Bartholdi's lighthouse project brought his career choices, at least temporarily, to a standstill. Despite his means and talent, despite his hunger for something big, something truly monumental to chisel, the job market for creating a colossus was severely depressed. What was he to do? To be sure, other smaller-sized commissions were offered and accepted. But it was the commission of a colossus he desired.

So it must have seemed that the time was right to embrace Laboulaye's grand notion of a Statue of Liberty. And yet this was problematic, as timing might be an issue. The intent was for the Lady to be given to America on its centennial in 1876, as was discussed at the Laboulaye dinner in 1865, but now it was 1869, and seven years didn't seem like enough time to finance, design, erect, and deliver a goddess. After all, the Washington Monument in Washington, D.C., begun in 1848, took more than three decades to complete.

The clock ticked.

Nevertheless, Bartholdi determined to turn misfortune into fortune. But first a war had to be fought.

The Franco-Prussian War of 1870–71

The Franco-Prussian War of 1870–71 arose as a result of a dispute between the Second French Empire of Napoleon III and the German states of the North German Confederation controlled by Prussia.

War ensued, and Bartholdi, representing the French government, served valiantly as a squadron leader of the National Guard and the Army of the Vosges and also participated in the losing fight for Colmar—his beloved hometown.

The war ended with France's defeat. Distraught over the outcome, Bartholdi constructed a number of monuments celebrating French heroism against the Prussians.

One of the results of the Franco-Prussian War was that large swathes of France were now occupied by the conquering Prussians. One of the occupation zones was Alsace, the province in which Bartholdi's hometown, Colmar, was located. As a result, Bartholdi could not legally return to the now "Prussified" Colmar unless he relinquished his French citizenship. This Bartholdi would never do.

At the same time France struggled to recover from the war, interest in the Statue of Liberty project coalesced in France. By 1875, Laboulaye and Bartholdi had formalized their fundraising efforts in France with the establishment of the Franco-American Union, whose mission was to raise funds for creating the Statue of Liberty. To help their efforts, fundraising was supported by French newspapers and other French organizations.

In America, however, fundraising dragged.

One likely reason was that the statue would sit on Bedloe's Island, located near

Facing page: *Hope of Many* (40˝ × 30˝)

the southern tip of Manhattan in upper New York bay. Bartholdi had scoped out the site on his first trip to America and had absolutely decided upon it. The problem was that non–New Yorkers saw New York City as the principal beneficiary of the statue. Why should non–New Yorkers contribute to the statue's pedestal and foundation? What was the payback?

Still, Bartholdi never gave up hope. After returning from America, he worked on the Statue of Liberty's design and construction in his Paris studio.

Just as important, too, he knew that he was the key to the entire venture's success. His now dear friend, Édouard René de Laboulaye, was frail and elderly and could

not travel to America to work with him on the project.

America: The Second Time Around

Bartholdi arrived in America on his second visit in early May 1876. And this time he was no longer unknown and was, in fact, greeted by friends and admirers. One of his first stops was the Philadelphia Centennial Exhibition, where the most mesmerizing, yet a bit jarring, display was the disembodied right arm of the Torch of Liberty; the length of her arm was 42´, the width of her arm was 12´, and an index finger was 8´. Some voiced concern that the sculptor must be

Those Who Wait
(40˝ × 60˝)

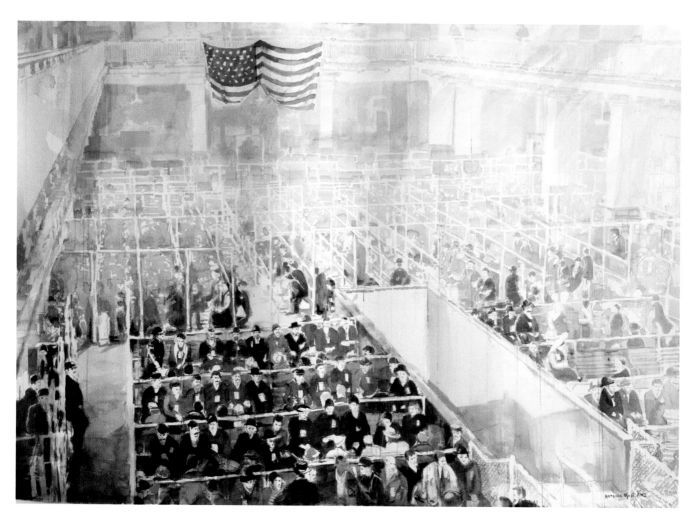

"mad" to create an arm without a body. Nevertheless, the Torch of Liberty was a sensation. Fifty cents bought a climb up a steel ladder leading to the Torch's balcony. (Eventually the Torch of Liberty was dismantled and shipped back to Bartholdi's studio in 1884 and attached to the finished statue.)

In America, a buzz surrounded Bartholdi. He smartly used newspapers and magazines to publicize his goddess. He cornered reporters, patrons, politicians, bankers, ordinary everyday citizens—anyone who would listen—and broadcast his colossus message. He was an excellent public relations practitioner, although public relations was yet to be formally invented until the twentieth century.

Interest continued. In New York City, a large illuminated picture of the proposed statue was placed on the New York Club building on Madison Avenue. The *New York Tribune* printed a glowing feature entitled "France's Monumental Gift to the United States." The city of Philadelphia, noting New York City's lackluster response to contributing to the cost of the pedestal and foundation, offered to financially support Bartholdi's dream if the statue were to be placed in the City of Brotherly Love. All was going swimmingly until the *New York Times* declared in error that the Statue of Liberty project had been suspended in Paris because of fundraising problems. The story was corrected, and the subsequent fallout led to the formation of The American Committee, which launched a national appeal for money.

Then, on George Washington's birthday, February 22, 1877, the Statue of Liberty was formally accepted by Congress as a gift from France.

Still, with all the hoopla surrounding Bartholdi's Lady, Americans—poor,

comfortable, or fabulously rich—would not dig far enough into their pockets to fully pay for the statue's pedestal and foundation. As a result, fundraising fell short by some $100,000—a sum any one of America's nineteenth-century tycoons could easily have afforded.

Moreover, the federal government refused to support the cause and only grudgingly provided funds at the last minute for the dedication ceremony. In New York state when $50,000 was appropriated by the legislature to help fund the pedestal and foundation, the bill was vetoed by then-Governor Grover Cleveland, who only two years later as president of the United States would shamelessly deliver gushing accolades at the statue's dedication ceremony.

Raising money in America was a serious issue. The entire project was in jeopardy. By 1884, it was difficult to imagine a dedication ceremony two years hence.

Marvin Trachtenberg writes in *The Statue of Liberty: Art in Content*:

> Things could have dragged on for years this way. It might have all come to naught, the components of Bartholdi's statue moldering away for years in their two-hundred-odd shipping cases—had it not been for the timely intervention of Joseph Pulitzer.

Working Stiffs Dig into Their Pockets

In 1883, Joseph Pulitzer purchased the newspaper the *World*, then losing some $40,000 a year, from Jay Gould, financier and legendary stock market gambler. Pulitzer's goal, simply put, was to expand readership and turn a mighty profit. Likely

Pulitzer's greatest gift was his understanding the wants of his readers and then finding the winding paths to satisfy them. His mantra was bold headlines, crime stories, gossip columns, and comic strips. Pulitzer understood that a newspaper needed to entertain as well as to deliver news.

In addition, Pulitzer eschewed the excesses of Gilded Age millionaires who mostly sat on their fat wallets instead of supporting worthy causes. Saving the Statue of Liberty project from failure seemed to Pulitzer, a Hungarian-born immigrant, a worthy cause.

To save it, he devised a clever moneymaking scheme featuring rousing editorials. He wasn't looking for big money donations. He was looking for small change from working stiffs. And, brilliantly, he published the names of each and every person who made a contribution, no matter how small.

Here is a sliver of a typical Pulitzer editorial on the subject of the Statue of Liberty published in the *World*, circa 1885.

> We must raise the money! The *World* is the people's paper, and now it appeals to the people to come forward and raise the money. The $250,000 that the making of the Statue cost was paid in by the masses of the French people—by the working men, the tradesmen, the shop girls, the artisans—by all, irrespective of class or condition. Let us respond in like manner. Let us not wait for the millionaires to give us this money. It is not a gift from the millionaires of France to the millionaires of America, but a gift of the whole people of France to the whole people of America.

Pulitzer's editorials were so successful that within several months the *World* had collected more than $100,000 (almost $2 million in today's dollars) in donations—most being $1 or less. When the campaign was done, some 125,000 people had contributed to the completion of the pedestal and foundation.

Ambition

Marvin Trachtenberg observes that for the most part, Bartholdi's work bears little discernible stamp of formal originality and resembles the output of a hundred other sculptors and monument makers of his era.

"However," adds Trachtenberg, "he [Bartholdi] did have one aesthetic passion—if it can be called that—a lust for the colossal."

Clearly, breathtaking scale inspired Bartholdi.

He also was fortunate.

Wealth smoothed his path.

And ambition fired a passion and an artistry that were ultimately attainable.

Bartholdi's job, apart from designing the Statue of Liberty, was selling the *idea* of the Statue of Liberty. He hadn't the grand flourishes of a Joseph Pulitzer. Or a P. T. Barnum, who had recently stampeded twenty-one elephants across the Brooklyn Bridge. Barnum's nifty ploy was triggered after the bridge's opening in 1883, when a woman tripped, screamed, and set off a panic that the bridge was collapsing. Twelve people were trampled to death, and confidence in the bridge's stability plummeted. Barnum's triumphant stampede had restored confidence in the bridge's safety—forever.

Bartholdi's method of persuasion—less ostentatious than Barnum's and Pulitzer's—was nevertheless effective. His method was person-to-person directness coupled with persistence. He bent the ear of anyone who would listen. And, in more than a decade of persuasion, he bent many an ear.

Antonio Masi, AWS

One chronicler of the times describes Bartholdi as an unsurpassed promoter of his own ambitious schemes.

As a consequence, Bartholdi's star, across the nation—and eventually the world—ascended. His Statue of Liberty would have a pedestal and a foundation in great part paid for by readers of the *World*. Further, the Statue of Liberty would have a permanent home in America on New York City's Bedloe's Island. And he and it would be the stuff of legend.

Today, more than one hundred years later, Bartholdi's tale seems remarkably American.

Realization

When I discover a subject grand enough, I will honor that subject by building the tallest statue in the world.

—Frédéric August Bartholdi

There is an attraction and a charm in the colossal that is not subject to ordinary theories of art.

—Alexandre-Gustave Eiffel

Inside [the Statue of Liberty] we seem to be looking up to the lantern of a gothic cathedral into dim distance. It is rather dark, but the gloom is pierced by thousands of little eyelets of light marking the holes left for the rivets.

—*The Morning News: The Latest Telegrams of the Day,*
Paris, 14 May 1884

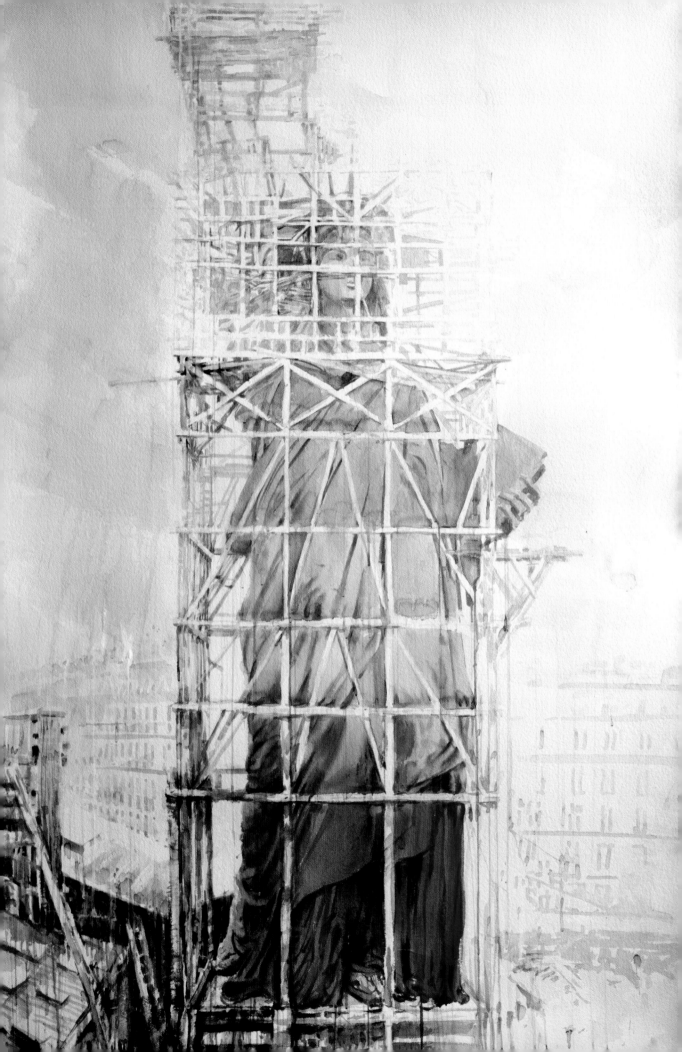

Magnificent feats of artistry and engineering were accomplished in the nineteenth century—the Eiffel Tower, the Brooklyn Bridge, and the Washington Monument, to name three.

Surely another notable nineteenth-century feat was the creation and construction of the Statue of Liberty, which principally employed two Frenchmen, Frédéric Auguste Bartholdi and Alexandre-Gustave Eiffel. Both were imbued with persistent ambition, exceptional creative skills, and a love of the colossal. One was an artist, the other a civil engineer.

Bartholdi and Eiffel were assisted by an army of some 600 skilled artisans and craftsmen trained in the tradition of French building skills dating back to the Middle Ages. The artisans and craftsmen were employed by the foundry Gaget, Gauthier et Cie workshops, which was tasked with building, assembling, and, last, disassembling the statue for shipment to America.

The foundry was located on what was, at the time, an undeveloped section on the northwest border of Paris, a few blocks from the Parc Monceau, one of the city's most elegant parks. Sometimes the statue was affectionately called "Lady of the Park."

Today the area has been transformed into a stylish neighborhood.

As Lady Liberty rose above the courtyard of the foundry, she was easily spotted from afar as she towered over Paris's low-slung nineteenth-century rooftops. As a result, she became a lively tourist attraction. Bartholdi ventured that some 300,000 people visited Gaget, Gauthier et Cie to view his rising Lady. In fact, throngs were so great that Bartholdi, forever searching for new ways to fundraise, decided to charge admission to view his Lady up close.

Writes Elizabeth Mitchell cheekily in *Liberty's Torch*:

> People went in droves to visit, particularly on Sunday, which a reporter pointed out "is the Parisian holiday for all sorts of diversions from sightseeing to a revolution."

Timing

Everyone toiling on the statue shared, whether consciously or unconsciously, a kindred destiny. By helping to create and build the colossus, they honored the American ideals of *life, liberty, and the pursuit of happiness* as well as the friendship between France and America. In committing to such a task, as political as it was artistic and technologically audacious, the notion of a statue was a tangible rejection of the repression of Napoleon III, who was deposed in 1873.

When Bartholdi returned from his first trip to America in 1871, he worked intermittently during the next four years designing and refining the statue's form. By 1875, he'd created a 4′ tall clay model of Lady Liberty, which was approved by Laboulaye and named "The Statue of Liberty Enlightening the World." That same year the Franco-American Union was created with Laboulaye as chairman to raise funds in France for Lady Liberty's construction.

In 1877, the American Committee for The Statue of Liberty was formed and charged with the seemingly Herculean job of fundraising for construction of the pedestal and foundation. Additionally, two other important events occurred in 1877: The U.S. Congress formally accepted the statue as a gift from the people of France, and President Ulysses S. Grant signed the bill officially designating Bedloe's Island as the statue's site.

Thus, the stage was set. And the timing was right.

Finally, with Napoleon III deposed and France now relatively stable politically, the creators of the goddess could pursue their labors without fear of imprisonment . . . or worse.

Sculptor

Bartholdi was the leader of the project, the chief and tireless promoter who had plotted the colossus's course from the rosebud of an idea.

But, above all, Bartholdi was a sculptor.

By the end of the 1870s, Bartholdi settled on Lady Liberty's size, 151.1′ from her base to the top of her torch. She would have a classical, rather stern face. Bartholdi tended to use family members as models. Some said that it was Bartholdi's mother, the severe Charlotte, who served as the model for the Statue of Liberty's rather dour face. Others speculated it was Bartholdi's wife, Jeanne-Emilie, who inspired the Statue of Liberty's face . . . and perhaps her torso, too. The issue remains a matter of conjecture, although Bartholdi, at one point, said his mother was the model.

Bartholdi seemed to encourage mysteries. For example, he would never confirm the obvious resemblance of Lady Liberty to his long-ago-rejected proposal for the Suez Canal lighthouse. Historians agree that the lighthouse, designed in the guise of a female holding a torch, undeniably resembled the Statue of Liberty.

One point was certain: The lighthouse reworked as Lady Liberty was an arresting sight.

Graceful drapery suggested a Roman goddess. Broken irons at her feet signified new freedoms. A seven-pronged tiara suggested the seven seas and continents of the world. A torch pointing to the heavens guided wayward travelers. And in her left hand, the Lady held a tablet engraved in Roman numerals that read, "July, IV, MDCCLXXVI," which celebrated the Declaration of Independence.

Each detail pointed to the statue's significance.

What Bartholdi had wrought was a profoundly powerful symbol of American values.

Colossal Task

At the outset, many design and engineering problems had to be resolved for the statue to safely and permanently stand in the windswept harbor of upper New York bay. The statue also needed to be transportable. In addition, funds needed to be raised for her pedestal and foundation, neither of which had yet been commissioned. As the gift was a joint Franco-American project, financing and building the base and pedestal were America's responsibility . . . so at this juncture, the outcome of the project was uncertain. Nevertheless, planning and building optimistically commenced and continued.

Photographs inside Gaget, Gauthier et Cie workshops demonstrate the vastness of the task. In one photograph, craftsmen, looking like the Munchkins in *The Wizard of Oz*, toil in the palm of Liberty's left hand, in which she clutches the tablet inscribed "July, IV, MDCCLXXVI." The tablet alone measured 23′7˝ tall and 13′7˝ wide—taller than three exceptionally tall humans standing atop one another's shoulders.

To build his statue, Bartholdi consulted Eugène Emmanuel Viollet-le-Duc, a mentor,

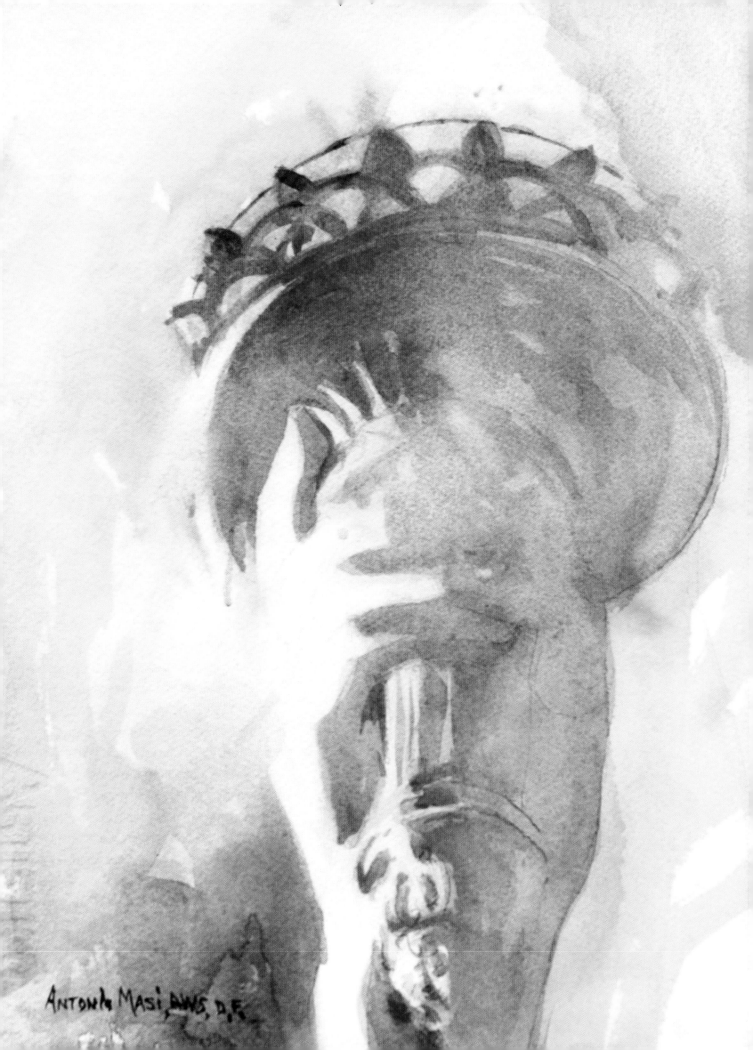

Antonio Masi, NWS, D.F.

In her extensive and studious book *Colossal: Engineering the Suez Canal, Statue of Liberty, Eiffel Tower, and Panama Canal*, Darcy Grimaldo Grigsby, professor of the History of Art at U.C. Berkeley, draws the distinctly different approaches between architect and engineer.

The architect [Viollet-le-Duc] had planned to pack the statue with sand-filled metal coffers, thereby updating the ballasting of the Colossus of Rhodes, which contained stone blocks inside its metal form

But Eiffel quickly came up with another plan.

Adds Grigsby:

Eiffel replaced the sand-filled interior with an inexpensive, simple iron armature upon which the thin sheets of copper would hang. He turned Bartholdi's metal woman into a skin covering a structural skeleton. The change was key to the statue's realization. After all, the scale, financial viability and transportability of the statue depended upon the hollowing out of the sculpture's interior and the use of strong, flexible, lightweight metal.

Further, Grigsby concludes, the Lady's internal structure would not rely on weight for support and stability. No old-fashioned sand or stone was a part of Eiffel's plan. Instead, he designed a tall central pylon to be the primary support structure of the statue's interior. The pylon was the central attachment point for lightweight truss work of complex asymmetrical girders. To connect the statue's copper skin to the pylon, flat metal bars were bolted at one end to the pylon and to the copper skin at the other end. While the bars held the statue together, they also created flexible suspension and acted like springs, allowing the statue to adjust to and accommodate the environment. If the structure had been too stiff, the flexing of the copper skin with the variation of wind pressure would cause the sheets of copper to fail because of metal fatigue and then fall apart.

The elasticity of Eiffel's design was key to the Lady's stability, and the result was a modern and flexible skeletal system.

What the inventive Eiffel delivered was exactly what Bartholdi required—a stable and transportable goddess.

Writes historian Edward Berenson:

Above all, The Statue of Liberty is a masterpiece of engineering and technology

And who would argue?

As the years have rolled by, those who honor the principles of modern engineering recognize that, in its day, Eiffel's skeletal design of The Statue of Liberty was revolutionary.

And, along the way, Eiffel surely disproved the adage that "Beauty is only skin deep."

Nearing the Finish . . .

By 1881, the statue's copper plates were completed and the first rivet had been driven. Thus began the colossus's assembly.

That same year, The American Committee appointed Richard Morris Hunt, described as a "fashionable" architect, to submit a detailed plan and later design the pedestal. By 1883, General Charles P. Stone was appointed chief engineer responsible for design and construction of the statue's 15´ thick concrete foundation as well as the construction of the pedestal. As all this was going on in New York City, the goddess's assembly continued in Paris.

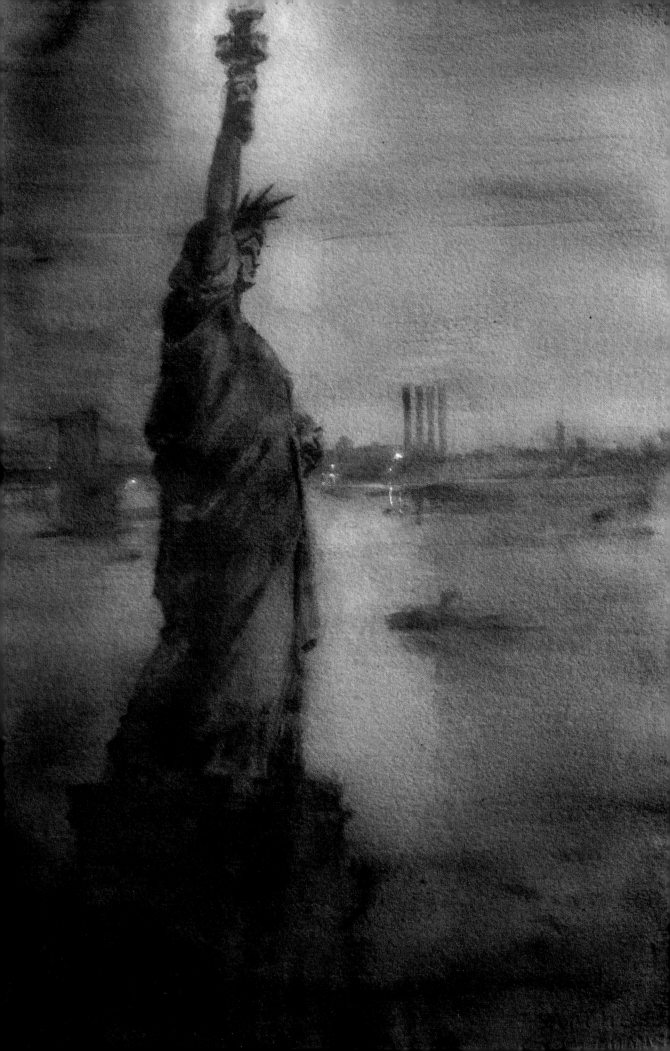

The Statue of Liberty's Measurements

Height from base to torch	151′1″
Pedestal foundation to tip of torch	305′1″
Heel to top of head	111′1″
Length of hand	16′5″
Index finger	8′
Head from chin to cranium	17′3″
Width of head	10′
Distance across the eyes	2′6″
Length of nose	4′6″
Length of right arm	42′
Width of right arm	12′
Length of sandal	25′
Width of waist	35′
Width of mouth	3′
Length of tablet	23′7″
Width of tablet	13′7″
Thickness of tablet	2′
Ground to top of pedestal	154′
Thickness of copper sheathing	3/32″

Credit: "Statue of Liberty National Monument" (U.S. National Park Service)

Finally, on July 4, 1884, the completely assembled statue was formally presented to Levi P. Morton, the U.S. minister to France. Some 300 people attended the ceremony held in the foundry of the statue's birth, the Gaget, Gauthier et Cie workshops.

Clearly, the French adored the statue and supported its creation. Wrote one smitten Frenchman: "It is not without profound regret that we will see it go. Our patriotism has dreamed of it elsewhere than on the other side of the ocean"

Indeed, feelings were so strong regarding the statue that Bartholdi built a replica for France. One-quarter the size of the original and a gift from the American community in Paris to the French people, the replica stands on a small island on the Seine.

The goddess's construction, assembly, and, finally, the final phase, disassembly, had taken four years, from 1881 to 1884.

As their final act, the army of artisans and craftsmen at the foundry packed more than 300 pieces of statuary into 214 wooden crates for the Lady's voyage by ship to America.

Coming to America

L'Isère, the French Navy ship, carried the Statue of Liberty across the Atlantic Ocean from Rouen, France, to New York's Bedloe's Island, landing on June 17, 1885. The dismantled and crated statue totaled approximately eighty tons of copper and twenty tons of metallic framework. The voyage was rough, but no damage was noted..

On Bedloe's Island, the Lady remained unassembled until Richard Morris Hunt's granite pedestal was completed in 1886. Soon after, the crates were unpacked and the statue's reassembly was completed in only four months by a reportedly "fearless construction crew," many of whom were new immigrants.

The first piece of the statue to be reconstructed was Eiffel's iron framework; the rest of the statue's elements followed. Construction materials were hoisted by steam-driven cranes and derricks. The last of the reconstruction, the Lady's face, was veiled upon completion until its removal at the dedication.

Finally, Finally . . .

On October 28, 1886, a decade after America's centennial, President Grover Cleveland and the throngs—politicians, dignitaries, honored guests, invited guests (overwhelmingly male)—and ordinary citizens roared their approval of Lady Liberty.

Bedloe's Island was packed.

A flotilla of ships and boats surrounded the island. And on New York's shoreline thousands gathered.

At this heart-stopping moment, let us not forget that only two women were allowed to attend the dedication on Bedloe's Island—Bartholdi's wife and the granddaughter of Ferdinand de Lessups.

The band of suffragettes who wished to attend the Bedloe's Island festivities were unwelcome. They could not properly (or even safely) celebrate Lady Liberty in their windswept rowboat. Yet they bravely joined the flotilla surrounding Bedloe's Island and delivered speeches about the lack of rights for women. Nor did poet Emma Lazarus join the merriment. No matter that she wrote the most enduring words that forever define the goddess. Nor did the journalists or readers of the audacious African-American newspaper the *Cleveland Gazette* celebrate with the Bedloe's Island elite. No matter! If they had their way, until the promises of liberty were kept, they'd "Shove the Bartholdi statue, torch and all, into the ocean"

Thus, a swell time was had by many, but not *all*.

Reality Bites

At last, the deed was done.

And the goddess, many agree, is and remains a magnificent feat of artistry and engineering.

But Lady Liberty is not an ordinary goddess. She is not the *Venus de Milo*, for example. She is not a goddess of sex and love.

She is categorically a goddess of *liberty*.

So when her dedication, however important, however merry, however righteous, didn't include *all*, what remains is merely a magnificent feat of artistry and engineering.

And that is not good enough.

Poetry

4

A good poem helps to change the shape of the universe

—Dylan Thomas

The tale of the Statue of Liberty turns in unforeseen ways.

Liberty's creators and supporters strove to construct a statue that celebrated the friendship between France and America. Lady Liberty also represented America the beautiful—a nation not founded on the basis of race, history, geography, or by chance but rather created on a set of beliefs that the Founding Fathers declared to be *self-evident*. And who passionately pledged, if necessary, to fight and die for their country.

"Give me liberty or give me death" was the rallying cry of the American Revolution.

Future Americans
(40″ × 26″)

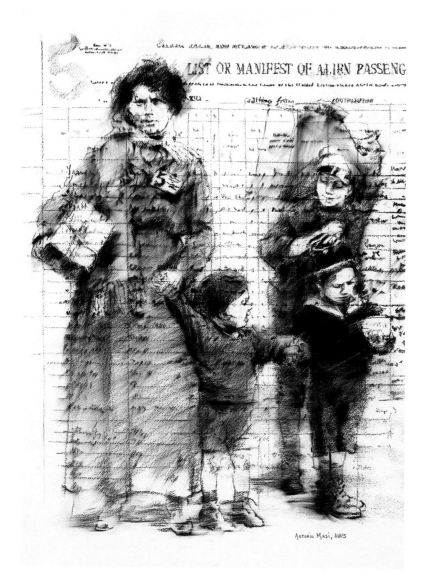

As it turned out, the intended messages of the Statue of Liberty did not resonate with America's late-nineteenth-century and early-twentieth-century refugees, immigrants, or, for that matter, Americans in general. And once the gaudy drama of the Lady's 1886 dedication was over, interest in the statue flagged—even more so as the statue's creators and supporters died.

Modernity

In retrospect, this upshot has a certain logic.

During the years leading up to the 1886 dedication and beyond, America struggled to recover from the Civil War, the death of President Lincoln, and a depression resulting in unprecedented debt. Although the Union had remained intact, ill-conceived and ill-fated Reconstruction policies took hold in the South and continued to divide the nation. Yet paralleling these events was the exploding Industrial Revolution, which engaged the nation's established and newly arrived citizens in their scramble to build their own lives while also building and rebuilding the nation.

The nation, truly ablaze with gritty optimism, was now a land where sharp, creative, and ambitious entrepreneurs could make a fortune.

In 1879, for example, Thomas Alva Edison publicly demonstrated his invention of the incandescent light bulb in Menlo Park.

"We will make electricity so cheap that only the rich will burn candles," Edison declared.

As late as 1880, 72 percent of Americans lived in rural communities. Richard Sears with his partner Alvah Roebuck foresaw an opening and founded Sears, Roebuck & Company, what would become the largest

catalog company in America. Dubbed the "Wishing Book," the catalog brilliantly offered city goods to country folk.

In the early nineteenth century rubber fever was rampant. Many believed rubber could have thousands of applications and make its inventors and manufacturers fabulously rich. But rubber in its natural state was unstable. It had to be vulcanized. Just about every scientist in the world was thinking about how to vulcanize rubber, including Charles Goodyear, not a scientist but a would-be inventor who pursued his

dream in his New England kitchen. And one day in 1839, a miracle happened.

As Goodyear experimented with a mixture of sulfur and rubber, he accidentally dropped the mixture on his hot stove and found, amazingly, that the rubber was not sticky but dry.

The result was that Goodyear had successfully vulcanized rubber simply by adding sulfur to the mixture. The rest is history. Today, rubber is used in millions of products, including the yearly production of 2 billion tires.

Those Who Came Before (30˝ × 40˝)

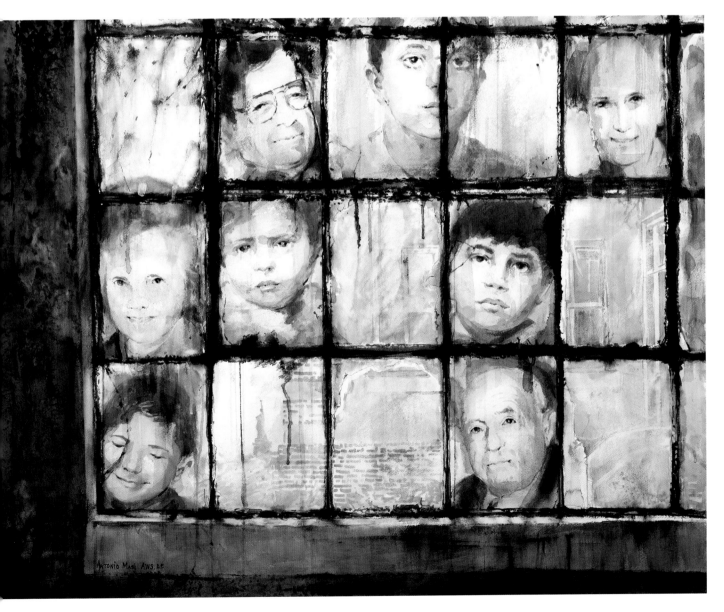

In 1883, the Brooklyn Bridge opened. Was not John Roebling's life the model for modernity and the great immigrant success story? In addition to bridge building, Roebling's creation and application of twisted wire ropes to haul cable and railway cars were a huge achievement. And in 1848, he founded The John Roebling's Sons Company in Trenton, New Jersey. Roebling's company would make him rich, revolutionize bridge building, and serve an expanding number of industries, including shipping, railroads, elevators, telegraphs, electricity, mining, and construction.

In 1909, the Queensboro Bridge (renamed in 2010 the Ed Koch Queensboro Bridge) and the Williamsburg Bridge opened. Seven other large-scale, long-span bridges would follow. And that was but a sliver of the growth in New York City.

Howard Johnson, a pioneering entrepreneur, invented the modern restaurant franchise and benefited greatly from the Industrial Revolution, most especially from the invention of refrigeration and from the growing proliferation of vehicles and the nation's burgeoning infrastructure of roads and highways. In 1929, Johnson opened his first restaurant and soon after invented the modern restaurant franchise. Johnson staked his empire on creating the highest-quality products—the crowning glory being perhaps the then-tastiest ice cream in the world. All twenty-eight flavors.

Writes E. L. Doctorow of this era in *Gotham Comes of Age*:

> People in every continent reason that if they can just reach our shores, they can scrabble up to a better life, or a more fighting kind of life where initiative can count for something.

The nation was a giant and buzzing marketplace, and, lost in this fabulous, scrambling, throbbing, and sometimes disheartening confluence was the icon, the gift from France honoring American principles and a long-ago war and friendships.

The fact was that most refugees, immigrants, and Americans did not connect to the Lady, nor did they connect to its French-crafted symbolism. How, then, did this disconnect morph into something else—indeed, something powerful and relevant?

Poetry Power

The answer resides in poetry and a time in America when immigrants felt welcomed and the *golden door* was, if not truly opened, at least ajar.

We already know Emma Lazarus's transcendent sonnet. We also know that she was not invited to the Statue of Liberty's dedication on Bedloe's Island. Nor was her sonnet read or even alluded to at the dedication. Nor were the subjects of her sonnet mentioned . . . those running from the *shark's mouth*, as poet Warsan Shire so frighteningly described in her poem *Home*.

By all reports, Emma Lazarus was a serious woman reared by a wealthy and established family of Portuguese Sephardic Jewish descent. As a result of her family's status, Emma moved comfortably throughout New York's high society. Her serene and advantaged life in New York City afforded her the luxury of writing without the need to earn a paycheck.

In the 1870s, Emma Lazarus became interested in a series of anti-Semitic incidents occurring in New York City and involved herself in charitable work for refugees at Wards Island, where she labored as an aide

Sonnets.

I.

The New Colossus.
Not like the brazen giant of [Greek fame,]
With conquering limbs astride [from land to land;]
Here at our sea-washed, sunset [gates shall stand]
A mighty woman with a torch, [whose flame]
Is the imprisoned lightning, and [her name]
Mother of Exiles. From her bea[con-hand]
Glows world-wide welcome; her [mild eyes command]
The air-bridged harbor that twin [cities frame.]

"Keep, ancient lands, your sto[ried pomp!" cries she]
With silent lips. "Give me your tired, your poor,
Your huddled masses yearning to breathe free,
The wretched refuse of your teeming shore.
Send these, the homeless, tempest-tost to me,
I lift my lamp beside the golden door!"

1883.
(Written in aid of Bartholdi Pedestal Fund.)

Antonio Masi AWS, DF.

assisting Jewish detainees. By the 1880s, when word of czarist Russia's *pogroms* spread, her anger and sympathy for these bloodied Jews began to infuse her writing, and she became a powerful voice on refugee issues, particularly Jewish refugee issues. She also was one of the foremost American proponents of what was not yet called Zionism—the establishment of a Jewish homeland in Palestine.

Emily Lazarus's life was short but splendid. She died tragically in 1887 of lymphoma, a year after the Lady's dedication. She was only thirty-eight years old.

Now, fast forward to 1901, fourteen years after Emma Lazarus's death. Georgina Schuyler, a friend of Emma's, while rummaging in a bookshop discovers a volume containing the then–largely forgotten sonnet *The New Colossus* and decides to mount a civic campaign to revive the work.

Schuyler was no ordinary citizen; she was a patron of the arts and a philanthropist who supported numerous social reforms. She also was a member of New York's elite high society and a direct descendant of Alexander Hamilton.

So, perhaps it is not surprising that on

Light in the Dark
(40″ × 60″)

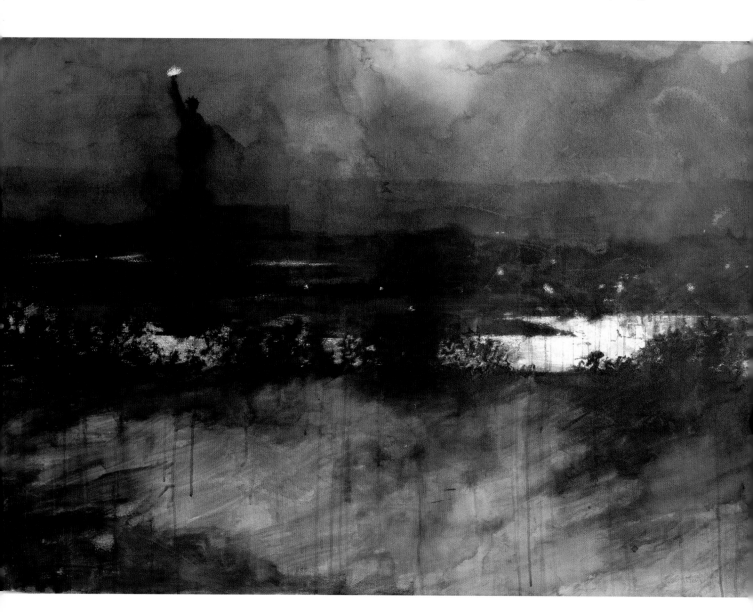

May 5, 1903, Schuyler succeeded in her efforts to have the sonnet's gripping plea, "Give me your tired, your poor, your huddled masses . . ." inscribed on a plaque and placed on the inner wall of the pedestal of the Statue of Liberty. (Today, the plaque is on display in the Statue of Liberty Exhibit in the statue's pedestal.)

No newspapers of the day reported on the plaque's placement, and there was no immediate public response to the plaque. But over time—some three decades—the message of Lazarus's sonnet penetrated and changed the trajectory of the Lady's symbolism.

Author and editor David Lehman in his 2004 *Smithsonian* magazine essay entitled "Without Emma Lazarus' Timeless Poem, Lady Liberty Would Be Just Another Statue," writes:

It was not until the 1930s, when Europeans in droves began seeking asylum from Fascist persecution, that the poem was rediscovered, and with it the growing recognition that it expressed the statue's true intention. Quoted in speeches, set to music by Irving Berlin, it ultimately melded with the statue itself as a source of patriotism and pride.

Emma Lazarus clearly had little interest in France's politics and purposes regarding the statue. For her, current events trumped history.

Writes historian Marvin Trachtenberg:

In her famous poem *The New Colossus*, the beacon of liberty seen across the sea was not intended to serve France or any other nation, but rather to guide those Europeans eager for a new life away from Europe entirely, to the "golden door" of America, where an uplifted torch was symbolic not of "enlightenment" but simply of "welcome."

Thus, from 1892, the year Ellis Island opened and through 1954, the year it closed, refugees and immigrants steamed past Bartholdi's soaring statue, landing, finally, on Ellis Island and thus beginning the often rigorous process of *passing through the portal*—that is, moving through the sometimes searing immigration process on Ellis Island on their way to becoming Americans.

What made the immigrant and refugee trials lighter was the notion of Lady Liberty's welcome so manifestly expressed by Lazarus's *The New Colossus*. This welcome gave the Statue of Liberty a heartfelt purpose and meaning. All of these facts stand, perhaps remarkably, since America's welcome mat has not always been reliably *out*.

Immigration

America is best when it has opened its arms

—Jon Meacham, historian

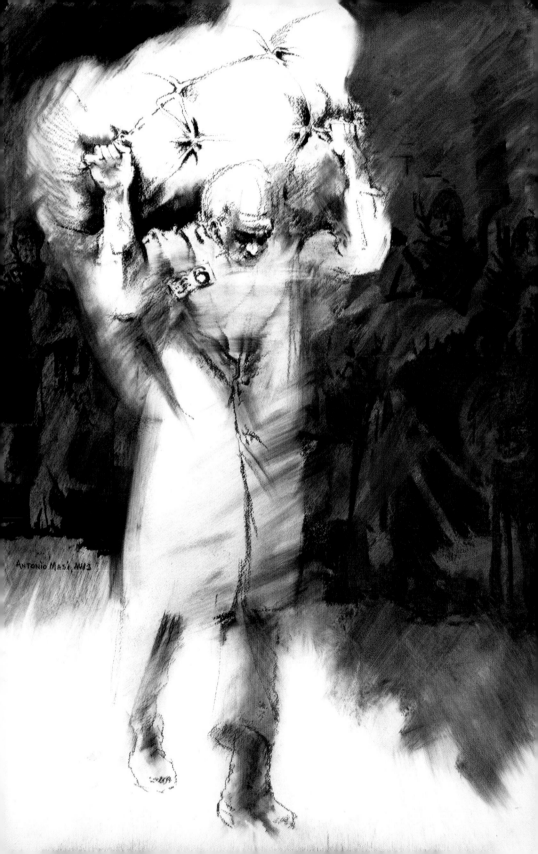

On April 10, 2018, the *New York Times* reported that Associate Justice of the U.S. Supreme Court Ruth Bader Ginsburg, then 85 years old and celebrating 25 years on the Court, traveled to the New-York Historical Society and presided over a naturalization ceremony of 201 citizens from 59 countries.

At the ceremony, Justice Ginsburg related that she was born in Brooklyn, New York, and that her father, Nathan Bader, was a Jewish immigrant who, at age thirteen, came to the United States from Odessa, Russia. She said her father arrived in America early in the twentieth century with no fortune and no ability to speak English. Yet here she stands—perhaps herself a bit awed—a member of the land's highest court administering the oath of citizenship.

"Alexis de Tocqueville wrote that the greatness of America lies not in being more enlightened than other nations," she said, "but rather in her ability to repair her faults." She acknowledged that the United States was at its outset an imperfect union and is still beset by poverty, low voting numbers, and by the "struggle to achieve greater understanding of each other across racial, religious and socio-economic lines."

In the audience were a mix of people—physicians, religious leaders, taxi drivers—with first names such as Islam, Hussein, Kazi, Angie, and Sunday.

"We are a nation made strong by people like you," she told them.

In the Beginning . . .

In 1776, the delegates to the Second Continental Congress met in Philadelphia, Pennsylvania, and signed the Declaration of Independence. As a result, millions would be guaranteed their unalienable rights of life, liberty, and the pursuit of happiness.

For native Americans, however, the struggle for their unalienable rights has been tortuous.

Beginning with the colonial period, the initial response of native Americans to the settlers was generally one of accommodation. However, accommodation turned to resistance with appropriation of Indian lands, exploitation, broken treaties, and the introduction of many new diseases spread by the foreigners.

Helen Hunt Jackson, born in 1830, was a poet, novelist, and activist and the daughter of Nathan Fiske, a professor at Amherst College in Massachusetts. As a young woman, she traveled widely around the world before returning to America and settling in Colorado Springs. In the West, she continued her journeys and witnessed first-hand the desperate plight of the American Indians.

In 1881, Jackson's book *A Century of Dishonor* scrutinized the history of U.S. Indian policies and its devastating consequences. She wrote:

> The history of the United States Government's repeated violations of faith with the Indians convicts us, as a nation, not only of having outraged the principles of justice, which are the basis of international law, and of having laid ourselves open to the accusation of both cruelty and perfidy, but of having made ourselves liable to all punishments which follow upon such sins—to arbitrary punishment at the hands of any civilized nation who might see fit to call us to account, and to that more certain natural punishment, which, sooner or later, as surely comes from evil-doing as harvest come from sown seed.

All in all, no accommodation was forthcoming. Native Americans would be unremittingly forced from their lands to make way for the new America . . . a bountiful nation in which native Americans would receive little or no bounty.

While Helen Hunt Jackson explored the West and expounded on the fate of native Americans during the early and mid–nineteenth century, immigrants and refugees continued to flock to America unfettered by immigration laws.

America's early settlers were mostly English, Dutch, French, Germans, Irish, and Scandinavians. They came from western and northern Europe and were sprung from Anglo-Saxon stock. They were often educated and easily assimilated into their new homeland. Many were farmers and laborers. Consider that John Roebling, superbly educated at the Royal Polytechnic Institute in Berlin and a star pupil of German philosopher Georg Wilhelm Friedrich Hegel, farmed in western Pennsylvania for six years before returning to his true profession of civil engineering and bridge building.

Fading Cordiality

Since the colonial era, people from many lands had freely entered America, but, as more and more kinds of immigrants came

New Faces of America (44½″ × 72″)

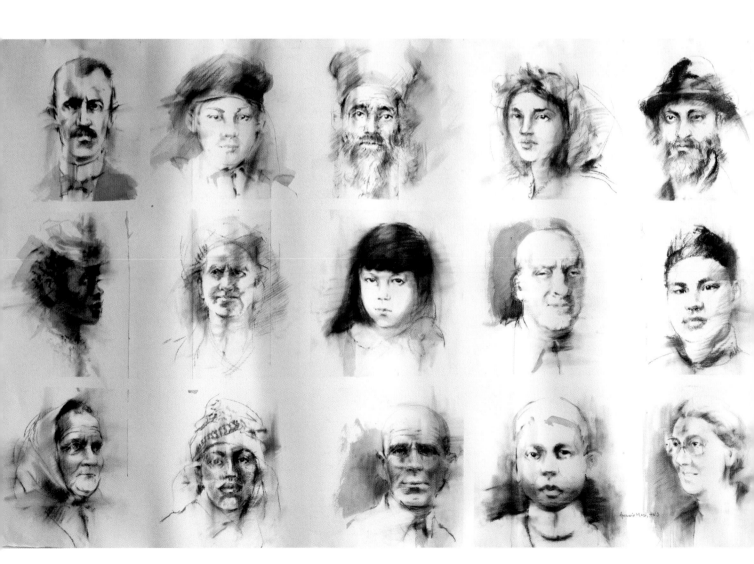

from different lands, America's welcome began to fade.

Just as the nation was about to celebrate its centennial, the U.S. government's first regulations on immigration were enacted. The Page Act of 1875 restricted the immigration of forced laborers coming from Asia. Seven years later, the Chinese Exclusion Act of 1882 halted all legal immigration of Chinese laborers and is today considered the first major exclusionary immigration restriction on an entire nationality enacted by America.

Chinese laborers, of course, were seminal to building America's railroads. And while the Acts of 1875 and 1882 resulted from the public's fear of the Chinese influence upon the labor market, the problems and issues of American nativism were not centered exclusively on the Chinese. What the Acts of 1875 and 1882 signified was a rising tide of nativism in the land generally and a growing suspicion of those who were different and who did not easily assimilate into American culture.

The sorrowful fact is that nativism already threaded through the young nation and focused on many groups.

"New Wave" Immigrants

Another reason prompting the truly sweeping changes in America's immigration policies was the arrival of a massive "new wave" of immigrants from eastern and southern Europe—Russia, Austria-Hungary, and Italy and other Mediterranean countries, running from the mid- to the late nineteenth century. Some 35 percent of these new immigrants were illiterate as compared with only 3 percent illiteracy among the Anglo-Saxons.

Moreover, these "new wave" immigrants, coming from different lands and cultures and mainly settling in large cities, added to the government challenges of housing, health, education, and sanitation. These newcomers also often preferred their Old Country customs and languages. Such issues lent cause to the deepening spread of nativism, as did the growing worries about dwindling employment opportunities, the waning of free homesteads in the West, and, in 1890, the official closing of the American frontier.

At the same time, a twisted national pride, likely kindled by the American centennial and pushed by organized labor, resulted in the rallying cry "Who shall respect a people who do not respect their own blood?"

And then there was the Know Nothing Party, which believed that a rising tide of immigrants, especially Roman Catholics, was a threat to the economic and political security of native-born Protestant Americans.

Donahoe's Magazine, a general-interest Catholic publication of the era, sourly observed that "Boston is no longer the Boston of the Endicotts and the Winthrops, but the Boston of the Collinses and the O'Briens."

Tyler Anbinder, in his ambitious volume *City of Dreams*, describes the plight of New York's "famine" Irish, who arrived in New York City during the mid–nineteenth century:

The famine Irish were the most impoverished immigrants ever to arrive in the United States and least prepared for life in New York. Only 12 percent had a trade, only two percent had been merchants or professionals. The rest would have to start life in America in the lowest-paying, most menial, least secure jobs.

The epic film *Gangs of New York* provides a brutal tableau of nineteenth-century New York. Amsterdam Vallon (Leonardo DiCaprio), a young Irish immigrant, is released from prison and returns to New York's Five Points—considered then to be the world's most notorious slum—seeking revenge against his father's killer, William Cutting (Daniel Day-Lewis), a sadistic, anti-immigrant, Protestant gang boss. Vallon, plotting his revenge, joins Cutting's inner circle. As the film progresses, Vallon's battle for revenge turns into not only a battle for his own survival but also a battle for the woefully downtrodden Irish.

In reality, each arriving group would have to find their place in America. Some just had a harder time than others.

Reports historian Arthur Meier Schlesinger in *The Rise of Modern America, 1865–1951*:

> Between 1865 and 1900 no fewer than thirteen and a half million people entered the United States—a total exceeding by more than a million the entire population in 1830—and the volume was to become larger.

Yet this metamorphosis, sometimes euphemistically referred to as the "great melting pot," consisted of brutal times in American history. This was, after all, also the cataclysmic era of the Civil War, which set the American people against one another and which ended with the assassination of President Abraham Lincoln.

"Inflamed by two generations of sectional controversy ending in four years of bloodshed," writes Schlesinger, "neither the victors nor the vanquished were in a fit mood to tackle the delicate task of mending the torn fabric of the Union."

It was in these brutal times that the nation was to be built and rebuilt. Moreover, the Industrial Revolution was humming. And, despite the tumult, Lady Liberty's creation, completion, and dedication, however incongruously, were to be realized.

Immigration in the Early Twentieth Century

From 1900 to 1920, nearly 24 million immigrants arrived during what is called the "Great Wave."

The tales of "Great Wave" immigrants from eastern Europe are reflected in the story of Grandma Ida, who with her family ran from poverty and oppression. Grandpa Francesco's story is reflected in the tale of southern European laborers, who were often lured by prepaid passage from American corporations to work for what seemed to them fantastical sums but were in truth exceedingly low wages to most Americans.

World War I, however, brought mass immigration to a grinding halt as the war inflamed even further many American suspicions and hostilities toward foreigners. Making matters worse, nativist and racist organizations, such as the Ku Klux Klan, terrorized African Americans, as well as Jews and Catholics.

A prime example of America's incipient racism is seen in D. W. Griffith's epic film *The Birth of a Nation*, released in 1914 and set during the Civil War and Reconstruction eras. The movie depicts African Americans as brutes unable to control their lust for white women. At the same time, the film romanticizes the actions of the Ku Klux Klan. Until *Gone with the Wind* was released in 1939, *The Birth of a Nation* was the highest-grossing movie ever made.

In 1914, the same year *The Birth of a*

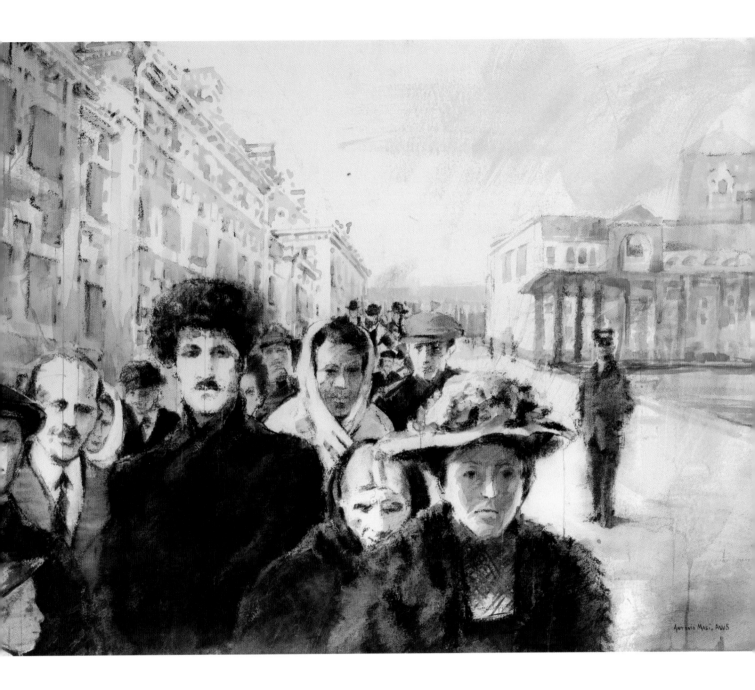

Arrivals (30˝ × 40˝)

Nation was released, some 800,000 immigrants came through Ellis Island. By the time the war was over in 1919, only some 26,000 immigrants had entered.

Landmark Johnson-Reed Act

Isolationism, racism, and nativism continued. And America's much-ballyhooed welcome would soon be officially and severely reduced even more with the 1924 Johnson-Reed Act, which drastically limited immigration by enacting permanent restrictions designed to keep out southern and eastern Europeans, particularly Italians and Jews, Africans, Middle Easterners, and Asians.

In essence, the Johnson-Reed Act was designed to dispense with America's "melting pot" and embraced a policy championing only new immigrants who looked, acted, and spoke like Americans.

This desire for sameness would prove to be a relentless American theme.

On April 27, 1924, in the *New York Times,* Senator David A. Reed of Pennsylvania, the bill's chief author, didn't shy from his goals. Wrote Reed:

> Each year's immigration should so far as possible be a miniature America, resembling in national origins the persons who are already settled in the country.

As a result, the 1924 Johnson-Reed Act set a restrictive quota system in place and immigration remained low through the end of World War II. Under the 1924 law, the number of immigrants admitted was officially slashed from 350,000 per year to 164,000 per year. Moreover, the Wall Street collapse in 1929 and the Great Depression, lasting through the 1930s, further slowed immigration.

Why come to America if the streets were no longer paved with gold?

World War II

Some six million Jews perished during World War II, yet only a few were allowed entry to America, as the nation's quota system contained no provisions for refugees.

In 1938, President Franklin Delano Roosevelt extended temporary visas to 15,000 refugees already in the country. This was an unpopular gesture, as the nation was still in a Depression and, no matter how great the need, refugees continued to be unwelcome. Matters grew even more desperate the following year when attempts failed to welcome 20,000 German (mostly Jewish) children into America. From 1933 to 1945, a total of some 250,000 refugees gained entry into the United States; many of these refugees were Jews or political opponents of fascism.

"We used to be more sensitive to human need," lamented First Lady Eleanor Roosevelt. Overall efforts to rescue the Jews of Europe by President Roosevelt and the First Lady failed.

Not to be forgotten during this period, too, was the illegal internment of Japanese Americans during World War II. Not until 1976 did President Gerald R. Ford issue a formal apology. And not until 1983 did the American Civil Liberties Union describe the affair as "the greatest deprivation of civil liberties by government in the country since slavery."

Ellis Island Closes

The saga of American immigration did not change much over the next fifteen years. In fact, immigration was so meager during World War II and the postwar years that by 1954, the government closed Ellis Island. (Ellis Island is discussed in detail in Chapter 6.)

"When Americans heard the words 'Ellis Island' in that era," writes Tyler Anbinder, "they conjured images of a detention center rather than an immigration depot."

The 1950s were the era of Senator Joseph McCarthy's communist witch-hunts, and, in a twelve-month period between 1953 and 1954, some 38,000 possible subversives were detained on Ellis Island. Such was the tenor of the nation.

A Fleeting Moment in Camelot

The 1960s brought the dawning of a new age abundant with elegance, optimism, intelligence, and the promise of positive

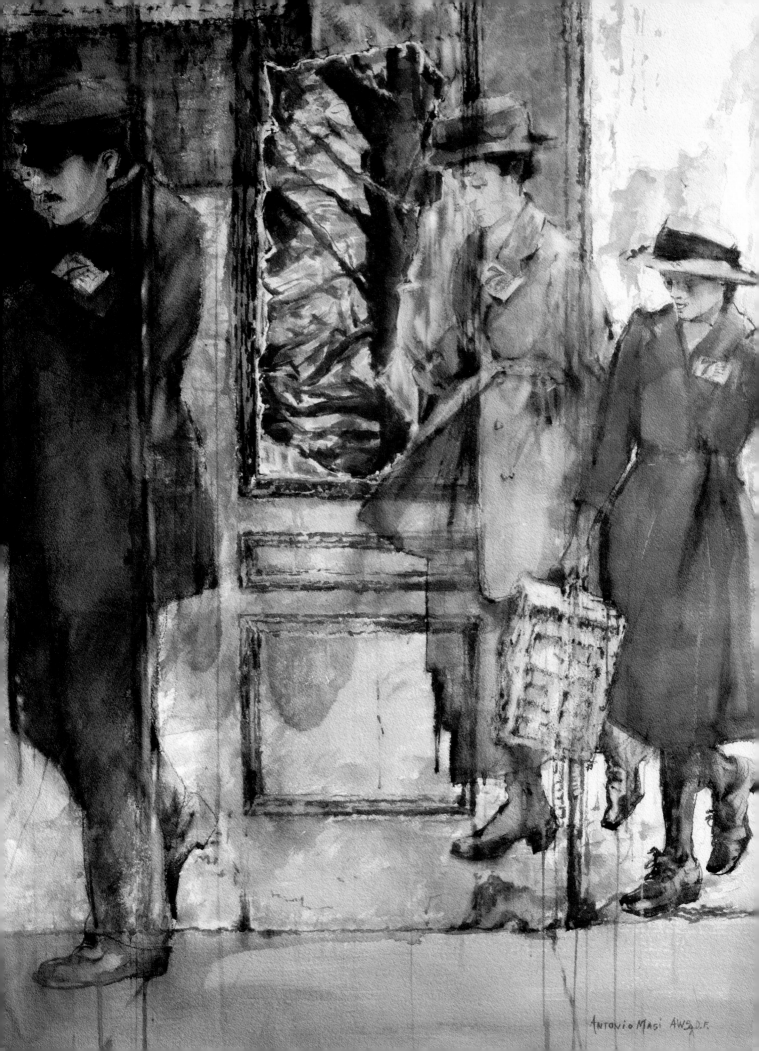

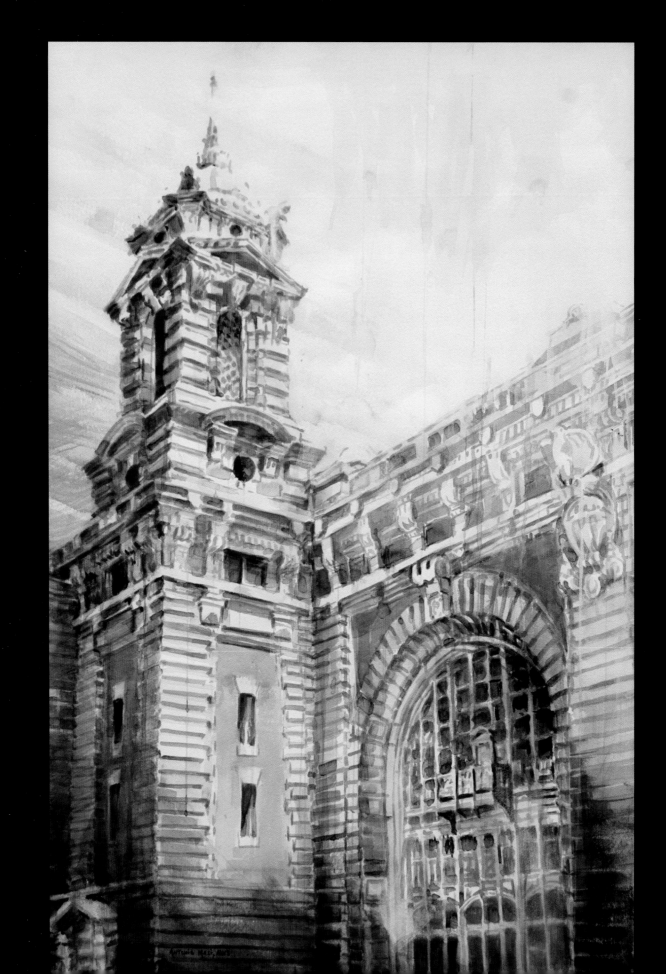

change. America and its allies had won World War II. The Marshall Plan was a success. Europe was being rebuilt. McCarthy was dead. Watergate was just another expensive apartment complex rising in Washington, D.C. And the civil rights era was in full swing.

In Washington, D.C., on January 20, 1961, America's thirty-fifth president, John Fitzgerald Kennedy, the nation's first Irish Catholic leader, was sworn in. It was a long road from 1848 when JFK's great-great-grandparents stepped from a ship onto the East Boston pier into a hostile and wide-open land. But, on that sunny and wintry day—little more than a century later—on full display was the quintessence of the American dream.

JFK and Immigration Reform

President Kennedy promised to reform the 1924 Johnson-Reed Act and its "national origins" quota system that discriminated against those seeking to come to the U.S from southern and eastern Europe. But JFK's halcyon moment was brief. By the end of the decade, President Kennedy, his brother Robert, and Dr. Martin Luther King Jr. were all dead. All murdered. And it would be left to JFK's successor, Lyndon Baines Johnson, to carry out the slain president's reforms.

The 1965 Immigration and Nationality Act officially committed the United States to accepting immigrants of all nationalities on a roughly equal basis. Most important, the law eliminated the use of national-origin quotas, under which the overwhelming majority of immigrant visas were set aside for people coming from northern and western Europe.

At the bill-signing ceremony, President Lyndon Johnson insisted, "The bill that we sign today is not a revolutionary bill."

But it was.

The Framers believed that large numbers of European immigrants would eagerly come to the United States. But European immigrants did not come in large numbers, as expected. Instead, many others came, particularly Asians and Latin Americans. Thus, the reality dawned over the next decades that America would not be returning to the "good ol' days" of Anglo-Saxon dominance.

In 2015, fifty years after the Act was passed, *The Atlantic* published an essay entitled "The Immigration Act That Inadvertently Changed America," by immigration expert Tom Gjelten. He reported:

> No law passed in the 20th century altered the country's demographic character quite so thoroughly

The *golden door* had swung open . . . in a monumentally unforeseen way.

1970s–1980s

As always, each new immigrant group that arrived in America had to find its own comfortable niche. The rosiest supposition was that every new group of immigrants would eventually find its niche. And, certainly, many did.

If America was at its "best when it has opened its arms," as historian Jon Meacham has stated so poetically, the subsequent decades following the 1965 Immigration and Nationality Act were hardly America's *best*, not only for new immigrants but also for many Americans, particularly working-class Americans.

Consider the following statistics published

Facing page:
Gateway (40″ × 26″)

The shining city that Ronald Reagan celebrated some three decades ago does not now exist in America. In today's America, the mantra is to build walls. And certainly not walls with doors that swing open to *anyone with the will and the heart to get here*. Yet there was a time in America, however briefly, when just about anyone with the will and the heart to get here was welcome.

John Augustus Roebling surely had the will and heart to get to America. And he was especially lucky to have an indomitable mother who made his grand voyage possible.

A Mother's Love

Friederike Roebling was intelligent, ambitious, and imbued with abundant energy. One thing she was not was a contented wife. Her indolent husband, Christoph Polycarpus Roebling, was a tobacconist who reportedly smoked more tobacco than he sold. Life was meager, at best. In addition, Friederike had five children to feed and clothe. She felt trapped in a dull place and a dull marriage that offered no hope of reprieve.

The Roeblings' sterling biographer David Steinman has evocatively detailed the family's tale.

The family Roebling lived in Mühlhausen, a sleepy village in what was then Prussia, and later Germany. In the early nineteenth century, in her misery Friederike divined but one slender hope. In her youngest son, John, she recognized a kindred spirit. John was sensitive and curious and possessed of a quick intelligence. This gave her an idea: The education of her gifted son would become her life's focus. And she dove into this

chore with a daunting ferocity. At last, she thought her life a worthy enterprise. And for this enterprise she labored day after day, week after week, year after year. She saved, salvaged, pinched, sacrificed, and more so that her beloved boy would not squander his life. She alone would see to it that he would be educated.

In this enterprise, as we now know, Friederike grandly succeeded. From the start, John Roebling was a first-rate student with an aptitude for drawing, engineering, and technology. Early on, he was fascinated with bridges and soon longed to be a builder of great long-span bridges.

In the early nineteenth century, one of the Napoleonic wars, the Battle of Jena, ended in a devastating defeat for Prussia. At Mühlhausen, less than one hundred miles away from the battle, the quietude of the Roeblings' village was inexorably shaken as unrest and battles continued. During the ensuing years, the fortunes and misfortunes of battles brought to Mühlhausen soldiers— Cossacks, Swedes, Frenchmen, Austrians, and many others. . . . These newcomers were a multitude of shades, their attire an amalgam of colors, their speech ringing with strange and alien languages. It must have dawned on a maturing, ambitious, and adventurous lad that beyond the walls of his village was a fascinating world.

Moreover, word in Germany about the freedoms and opportunities in America was spreading. It also must have dawned on Friederike that for John Roebling to succeed, for him to have the life she wanted for him, he would one day have to forsake her and all he knew and seek his glory elsewhere, perhaps even as far away as America.

In his diary, John plainly stated his distaste for German politics:

Nothing can be done in Germany with an army of councilors, ministers, and other officials discussing the matter for ten years, making long journeys, and writing long reports

Although a government job offered John security, the bureaucratic life was not for him, especially because the possibility of adventure, opportunity, and freedom now beckoned.

Finally, John made his decision, and Friederike, trusting her son's judgment, quietly accepted it. Wanting to see him off on his grand adventure, she made the arduous seven-day journey from Mühlhausen in a stagecoach to the Bremen seaport to bid him farewell.

It was early morning, and the date was May 22, 1831. At this dour moment, Friederike pressed a small amount of money

Golden Door
(40˝ × 53˝)

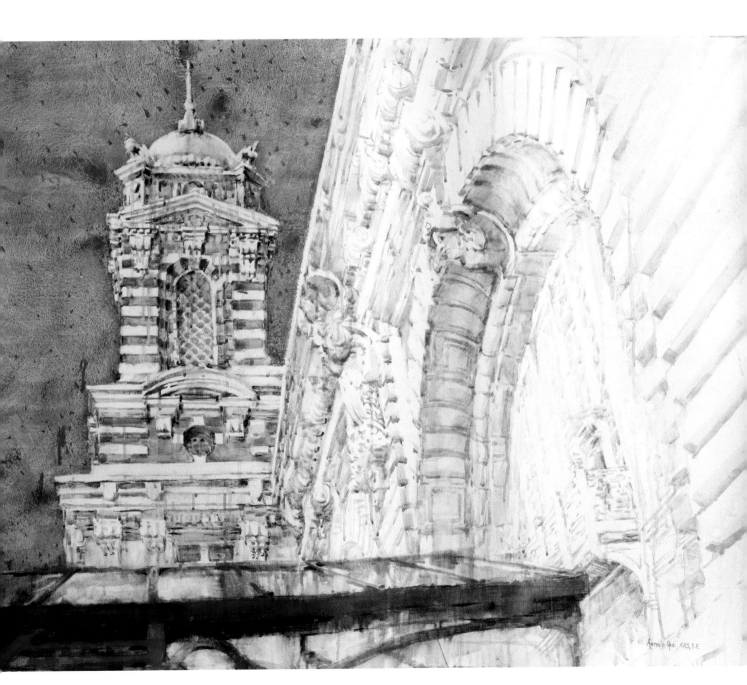

into John's palm, her final gift to a beloved son.

John's ship, the *August Eduard*, was a small sailing vessel carrying a jam-packed load of ninety-three passengers. Luckily, he was able to secure a cabin and avoid the hardships of steerage. As the *August Eduard* slipped below the horizon, Friederike suddenly fell ill, suffered a heart attack, and collapsed. Resolute as ever, she did not perish on the pier. Instead, she held on long enough until finally after more than two months she learned that John had arrived safely in America on August 6, 1831.

"Her work was done," writes Steinman.

John Roebling never returned to Mühlhausen.

Upon arriving in America, he freely ambled down the ship's gangplank into the promised land. His timing was perfect. In the New World, he was golden—a highly educated, highly competent, and highly prized white male.

Yet trouble brewed in America.

The warm welcome accorded John Roebling, and others like him, would not be so generously extended to the next crowd landing in America. As noted earlier, from the mid–nineteenth century through the early twentieth century, the so-called new wave and Great Wave immigrants came from Russia, Austria-Hungary, Italy, and the Mediterranean countries. Traveling in steerage, they were poor and typically uneducated. Some Americans felt that these newcomers sullied the nation's pristine pool of Roebling-like Anglo-Saxons.

The sheer numbers arriving astounded: Between 1865 and 1900, some 13.5 million people entered the country—a total exceeding by more than a million the entire U.S.

population in 1830, one year before John Roebling's arrival.

The result of this deluge was an increasing number of new and restrictive national policies. By 1891, Congress had passed comprehensive federal immigration legislation, and a Bureau of Immigration was in control. *Control* was now pointedly aimed at the so-called wretched refuse—in other words, passengers in steerage.

Thus, a turbulent era in America's immigration history would grow even more turbulent.

Imagine

Now imagine that it is the late nineteenth century to the early twentieth century, and you are one of those so-called "wretched refuse" imprisoned in steerage and bound for the New World. (Sadly, Grandma Ida isn't around to sweeten the tale.) Your passage has been long and rocky across the North Atlantic. The rolling of the ship adds to your misery in a crowded and poorly ventilated hell. The hatches are sealed. The air stinks of vomit, urine, and feces. You are spent as you brood about what you've left. Your old world is gone. Disappeared from the horizon you could not see. So too, perhaps forever, your parents, siblings, and friends. Your town is gone, too, though it was likely shabby and sometimes dangerous. Still, it was familiar. It was home.

Finally, after weeks at sea, New York beckons. If you are fortunate, the ship's captain will release you from steerage to see from the open deck the great metropolis as you sail into the harbor.

If so, you will surely see Lady Liberty and her upraised torch.

Perhaps you know that Bartholdi, on his

first trip to America in 1871, sailed into New York harbor and spied Bedloe's Island (now Liberty Island) and instantly decided that was where his Lady belonged.

You might also see the Gothic towers of the Brooklyn Bridge or the spire of Trinity Church or the rising buildings of lower Manhattan.

You are in America, finally, yes, yes, yes.

Yet one formidable hurdle must be cleared before that mythical golden door swings open.

Passing through the Portal

Many have referred to Ellis Island as an "Island of Hope."

Others have referred to Ellis Island as an "Island of Tears."

Located in upper New York bay—closer to New Jersey than to New York—Ellis Island was the gateway for more than 12 million immigrants to the United States. It also was the nation's busiest immigrant station center for more than sixty years, from 1892 until 1954.

(Earlier immigrants entered through Castle Garden, opened in 1855 and closed in 1890. Located at the Battery in lower Manhattan, Castle Garden was the nation's first official immigration center.)

Second- and third-class passengers received cursory medical inspections, usually on board their ships. Passengers able to afford first class did not have to submit to a medical inspection. Their entry into America was automatic. They freely ambled down the gangplank into the promised land. Bottom line: The government opined that a person who traveled first-class was well-to-do, healthy, and unlikely to become a public charge.

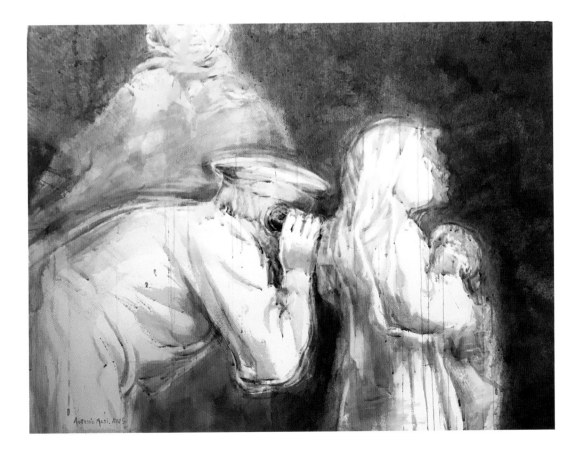

Examination
(30˝ × 40˝)

Ships delivering immigrants to New York usually docked in lower Manhattan. Upon docking, steerage passengers remained below as cabin-class passengers disembarked. Sometimes the press of immigrants at Ellis Island was so great that newly arrived steerage passengers were forced to spend additional days and nights in the ship's hold. When passengers were finally released from steerage, they crowded onto the ship's deck and were given a quick preliminary screening by a doctor to determine if anyone had a serious or contagious illness. If so, the passenger (children included) was quarantined and sent to Ellis Island Hospital, a twenty-two-building hospital complex, one of the largest public health undertakings in U.S. history and, at the time, one of the best infectious disease facilities in the world.

The doctors and immigration inspectors scrawled chalk marks on the backs of passengers.

"A chalk mark—given to about one in five immigrants—meant separation from family, an involuntary hospital stay and,

Button Hook
(30″ × 40″)

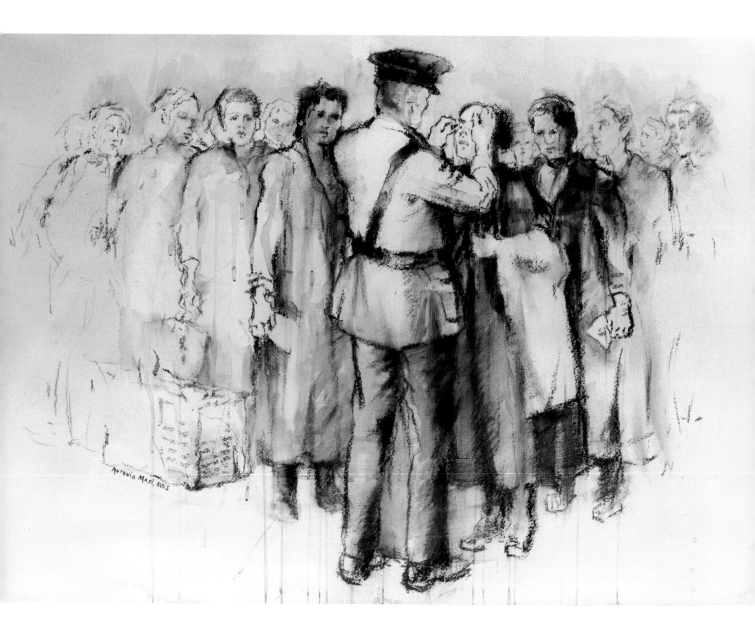

possibly, deportation," wrote Sewell Chan in a 2007 article on Ellis Island in the *New York Times*.

A now-elderly immigrant remembered how he was as a child separated from his mother and held for observation in the Ellis Island Hospital.

"I was here in this place away from her, never knowing if I was going to see her again," he said.

Ellis Island, a veritable Tower of Babel, was filled with immigrants speaking myriad dialects and languages. Misunderstandings occurred, despite a small army of translators. Eventually the young man was returned to his mother, and they successfully passed through the portal.

Lorie Conway, a documentarian who wrote and directed *Forgotten Ellis Island*, spent almost a decade working on her project and offers insights into the healthcare at the hospital:

Some children—those with potentially deadly contagious diseases—were placed in quarantine, apart from their parents who were not allowed to visit them. Nonetheless, they were made to feel safe and at home. The hospital complex on Ellis Island had a school, a library, weekly movies, social and legal aid workers, and chaplains who made regular visits to the sick wards. Holidays were celebrated with candy and gifts. There was a kosher kitchen and other accommodations for those who, by virtue of their religion or culture, had special dietary needs.

Immigrant children at Ellis Island Hospital were tracked, treated, often healed, and then safely returned to their parents. According to Conway, parents knew where their children were, and if the children were not deemed contagious, they could visit with them.

Further she added:

There can be good reasons for separating parent and child at a U.S. point of entry. There are also capricious reasons. There was never a time when caprice was a governing policy at Ellis Island Hospital.

This was remarkable given that the era was awash in nativism and some Americans, worried about their own economic futures, viewed spending so much money for free medical and hospital care on the so-called American invasion as wasteful. Yet despite public concerns, goodness prevailed at Ellis Island Hospital, and that goodness today stands in contrast to the Trump administration's immigration policy of separating— often permanently—children from their parents at the southern border.

Ellis Island Hospital was the gold standard of humanitarian operations. Moreover, no major epidemic was ever traced to an immigrant who entered America after being treated at the hospital, and nine of ten patients treated at the hospital were cured and allowed to enter the country. This was quite a feat, as antibiotics were not yet available.

"One would like to think, a century later, that we're a more advanced society," says Conway. "One would also like to think that people today would more easily understand the plight of the migrant."

Ellis Island Hospital, in decline since the 1920s, officially closed in 1954.

Small-time Grifters

While medical treatment on Ellis Island was good, everything else that happened on Ellis Island was fraught with peril.

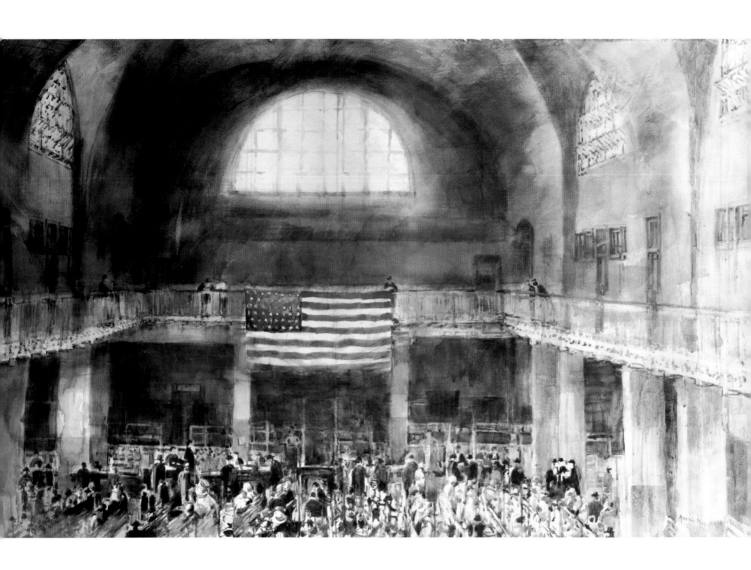

The Great Hall
(41½″ × 67¼″)

Some immigrants, obviously ill, were immediately sent to Ellis Island Hospital directly from their ships. Passage through the portal then began in earnest for the remaining passengers, who, finally, were allowed to disembark. Terra firma, at last. But not for long. Struggling with their children and belongings—sacks, bundles, baskets, suitcases, backpacks, rucksacks, crumpled packages—they were swiftly crammed onto ferries or barges and hauled the fifteen-minute, half-mile to Ellis Island.

In the book *Imported Americans*, author Broughton Brandenburg describes how ". . . the dock men displayed great unnecessary roughness, sometimes shoving them

violently, prodding them with sticks . . . as they hustled the immigrants onto the ferries and barges."

Finally, at Ellis Island, the immigrants climbed the staircase to the Registry Hall in Ellis Island's sprawling main building. This was the immigrant's first test on Ellis Island. But most didn't know it. Looking on from above the staircase, inspectors secretly eyed each immigrant, searching for any indications of infirmities, while shouting and shoving guards further unnerved the spent and likely confused travelers.

As the immigrants approached the top of the steps, chalk markings on the backs of immigrants were sometimes added. The

letter *B* signified a possible back injury, *L* for lameness, and so on.

In 1907, more than 11,000 immigrants went through Ellis Island in just one day. A record.

But long lines and rough handling were the least of a steerage passenger's problems. So was the dreadful voyage. The seasickness. The inability to wash, to wear clean clothes, to sleep, to see the sky, to be alone, to read, to eat properly.

Making matters worse, some Ellis Island workers preyed on the immigrants. Some demanded bribes in exchange for admittance. Some required the promise of sex after admittance. Some money changers shortchanged the "greenhorns." Some concessionaires overcharged for food and drink. Some railroad clerks overcharged for tickets.

The Registry Hall in the main building of Ellis Island was a despotic scene—an updated Dante's *Inferno*—often peopled by small-time grifters preying on the immigrants.

Yet all of these offenses were nothing compared with the gut-wrenching terror of deportation. In the end, each life turned on the verdict of the doctors, inspectors, and translators—and there seemed an army of them to persuade.

Yet the entire period of grilling would last on average only a few minutes, sometimes less. The eye exam lasted approximately thirty seconds or less. In fact, most immigrants went through the entire Ellis Island process in just a few hours if they were not sent to the hospital.

In 1901, to his credit, President Theodore Roosevelt set in place a series of reforms at Ellis Island. His stated ". . . goal was to run Ellis Island as a hospitable service center for the new American, not as a pool for thievery. . . ."

Medical Exams

Lined up like cattle in pens, tagged with a number, immigrants waited their turn to be examined and questioned. (In 1911, the pens were replaced with benches.) Inspectors studied each immigrant: Was there an unseen or unknown malady? Deafness? A cough? An infection? A heart defect? A breathing problem? Asthma or tuberculosis? Why was a child weeping incessantly? Was the child sick? Why did a woman hide her face behind a veil? Why was a woman wearing a winter coat in July? Why did someone lean against

Processing
(40″ × 26″)

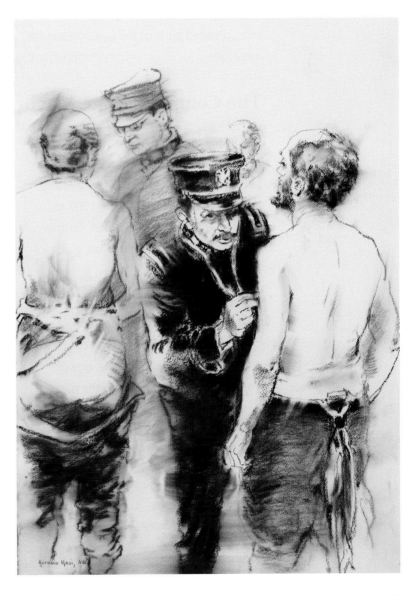

Promises

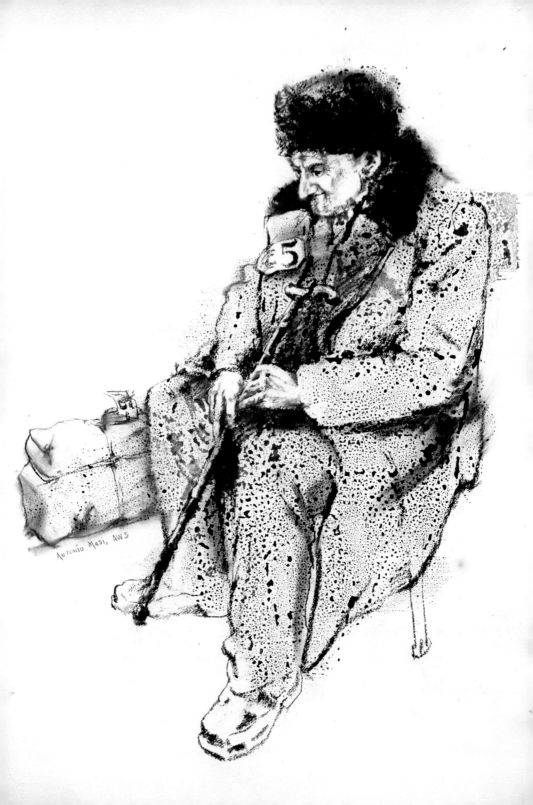

Today, most immigrants and refugees arrive by plane and thus miss the majestic experience of passing by Lady Liberty. As a result, they never experience the Lady's welcoming reach and may never fully grasp the crucial implications of her extravagant promises.

But not so Antonio Masi.

To this day—now more than seven decades ago—he remembers his family's tremendous feelings of relief mixed with joy upon first glimpsing the Statue of Liberty. The Masi brood—eight children and their parents—stood transfixed upon the ship's deck as it sailed past the Lady and into New York harbor.

"When I first saw the Statue of Liberty," he remembers, "for the first time in my life, I felt *safe*." He was nearly eight years old.

I have my memories, too. I still vividly recall Grandma Ida's excitement in retelling her own tale of passage when I was a little girl on the beach in Rockaway.

She'd finally arrived in the "*Goldine Madina*." Like Antonio, she was almost eight, too.

Her eyes glimmered as she spoke. And she patted my head.

"Joanie, someday I promise I will take you to see that great Lady with the upraised torch in her hand."

Someday . . . someday

How many millions of times has the saga of passage been told and retold?

And will it continue to be told? And how will it continue to be told?

To Be American

John Roebling lived his American dream.

It was a full life abundant with splendid accomplishments, brimming with patriotism and, as in all our lives, some heartbreak.

By 1852, after little more than two decades in America, John Roebling, already a bridge builder of note, contemplated an East River bridge joining the cities of Brooklyn and New York. (New York and its boroughs would be consolidated in 1898.) What impelled Roebling's idea was a long crossing he'd taken from Brooklyn to New York on a crowded ferry on an ice-choked East River. Roebling saw that a dry passage across the river was the solution to the slow and crowded ferries on the busy and oft-dangerous East River.

Thus began John Roebling's campaign to build his Great Bridge.

But a national crisis loomed. Soon a fearsome cloud would descend upon a fractured nation, and its citizens would be unimaginably shaken.

On February 21, 1861, John Roebling and his eldest son, Washington Augustus Roebling, then twenty-four years old, attended a short speech made by then–President-elect Abraham Lincoln, who had stopped briefly in Trenton, New Jersey, on his way to his inauguration in Washington, D.C. Young Washington, already a civil engineer, had graduated in 1857 from Rensselaer Polytechnic Institute and joined his father as a "right-hand" man in the work of building bridges.

As related by David Steinman in *The Builders of the Bridge*:

> The Roeblings, father and son, heard the address, eloquent in its simple sincerity. Their earlier sympathies were strengthened; and from that day they were resolved, should the need arise, to support the President in his efforts to preserve

the Union, even if Civil War was the price that had to be paid. But each kept their thoughts to themselves.

Then, on April 12, 1861, southern troops attacked Fort Sumter, and shortly thereafter President Lincoln called for 75,000 volunteers to join the Union Army.

According to Steinman, Roebling family lore has it that on that particular evening John and Washington Roebling had dinner together at the family home in New Jersey. Both were silently thinking of the president's call for volunteers when John Roebling turned to his son and said, "Don't you think you have stretched your legs under my mahogany table long enough?"

Washington silently rose, left the table and the house, and enlisted in the Union Army the next morning. Washington Roebling's saga would be every bit as charged as his father's. But that was in the future.

Building the Brooklyn Bridge

Finally, after more than a decade of politicking for the bridge, John Roebling was appointed, on May 23, 1867, chief engineer of the "Great Bridge Project." The following September, he delivered his plans to the New York Bridge Company, the body charged by the New York legislature to build the bridge.

Upon completion, the Brooklyn Bridge would be the world's longest suspension span, measuring 1,595′5″ tower to tower; containing 14,060 miles of rope; weighing 14,680 tons; and costing $15.1 million. Roebling's Great Bridge also would mark the first use of steel as a material for bridge wire.

Work on the new bridge would soon start.

On a July morning in 1869, John Roebling, sixty-three years old, stood near pilings at a ferry slip on the Brooklyn shoreline taking compass readings. He didn't notice a docking boat approach, touch the slip, and tumble the pilings, which fell and crushed his foot.

All his life John Roebling had rejected conventional medicine. Now, in his grimmest hour, he stubbornly rejected treatment. Three weeks after the accident, John Roebling, the apostle of steel, the world's foremost authority on suspension bridges, and the man entrusted with designing and building the world's greatest bridge, died of tetanus.

Suddenly the Brooklyn Bridge had a new chief engineer. Washington Augustus Roebling, thirty-two years old, was the logical choice to succeed his father in that role. Washington had returned a Civil War hero and now bore the rank of colonel.

The saga of the Roeblings in many ways parallels the persistently ambitious story of America.

The Roeblings were creative, patriotic, audacious, enterprising, and hardworking. They saw and seized opportunities. They made the most and best of their lives . . . and except for that one moment when John Roebling freely ambled down the gangplank of the *August Eduard,* everything he gained in America, he earned.

John Roebling did not live to see the Statue of Liberty rise, but he would have understood its significance. As did those attendees of that fateful and long-ago dinner party.

A Monumental Notion

What began in 1865 in Glatigny, France, at a dinner party hosted by esteemed university professor Édouard René de Laboulaye and

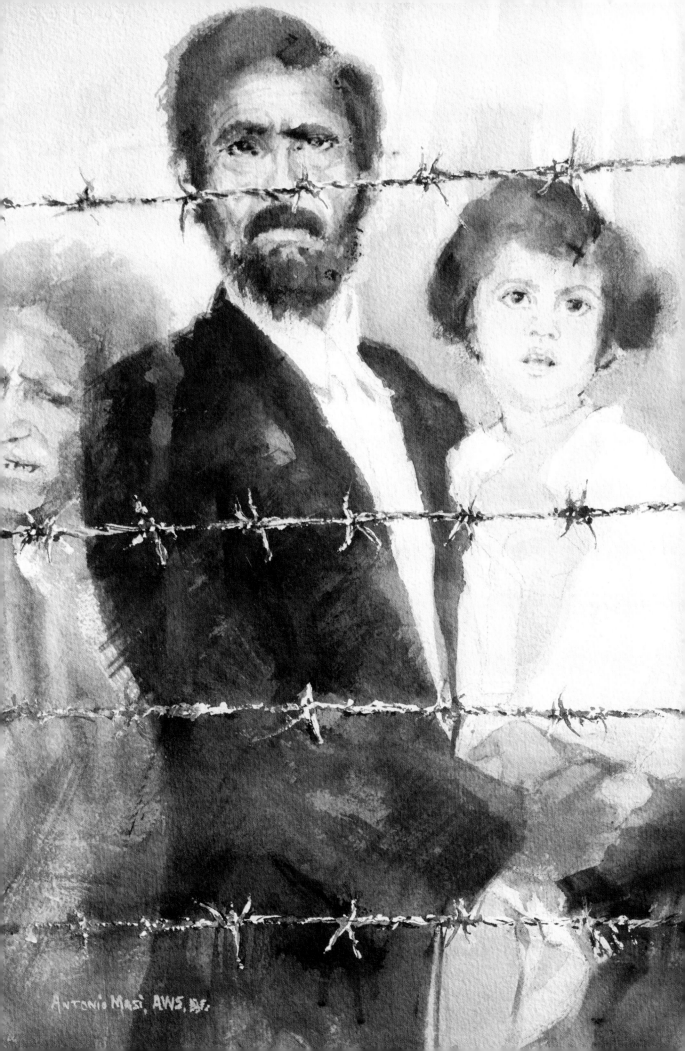

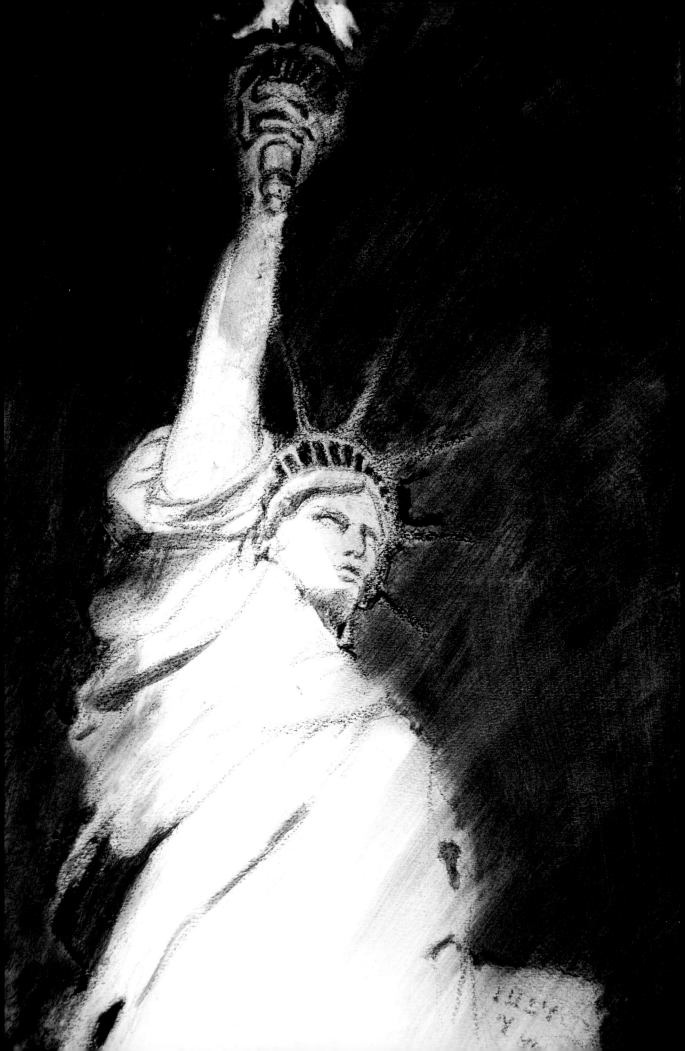

attended, among others, by a promising young sculptor, Frédéric Auguste Bartholdi, was the extravagant notion of creating and giving a monumental statue to America that celebrated the young nation's ideals.

Laboulaye was in 1865 France's leading expert on the United States and much preferred the American political system over France's system and its then–autocratic ruler Napoleon III.

Writes Edward Berenson:

The Frenchman [Laboulaye] liked America's strong tradition of individual liberty, the checks and balances that limited the size and reach of government, and its optimistic belief in individual advancement.

Bartholdi, and later the civil engineer Alexandre-Gustave Eiffel, caught the spirit of the project and thus began the epic struggle to create, build, transport, and pay for the monument, base, and pedestal. Although the Statue of Liberty was to be a gift from France, the cost of its creation was meant to be shared with America. Yet in America, fundraising dragged. As it would stand in New York's harbor, most Americans living beyond the city's borders felt that New Yorkers should pay for it. Affluent donors as well as the U.S. and New York state governments were slow to contribute and tightfisted when they did. Had it not been for Joseph Pulitzer's flashy fundraising campaign in the *World*, the entire project likely would have collapsed.

Promises

The name says it all: the Statue of *Liberty*.

America offered liberty and the right to live one's life unencumbered—that is, without fear and with a rule of law and a government that derived its power from the consent of the people it governed.

How this novel idea must have appealed to the early settlers and those who followed. What a thrill that first sighting of the Statue of Liberty must have been—especially to late-nineteenth-century and early-twentieth-century refugees and immigrants. Yet, at that iconic moment, the destiny of each of these travelers was uncertain. Passing through the portal was a misery. As it turned out, the Statue of Liberty likely provided the warmest welcome these weary travelers received.

James B. Bell and Richard I. Abrams in a special centennial commemorative book entitled *In Search of Liberty* provided a celebratory context.

We have had a century to take this Lady of Light into our very hearts and make her an integral part of our own national spirit and consciousness.

But remember, Bell and Abrams's affectionate prose was written more than thirty years ago.

What does this epic gift from the French truly represent today in the gnawing miseries of the twenty-first century?

Is America a nation that continues to welcome refugees and immigrants? Is it a land where many different types of people blend into one nation, and where Jeffersonian ideals have remained sacred? Is the goddess today truly "an integral part of our own national spirit and consciousness"?

If not, then the goddess, impressive as she appears, is today a hollow icon. The promises of yesteryear forfeited.

Then what remains?

Perhaps a mini–history lesson filled with disappointments. Or a day trip to Liberty

Island for the kids on a Sunday afternoon. A choice between Grant's Tomb or the goddess.

Given the politics of the day, how can anyone still believe that the Statue of Liberty accurately reflects America's welcome? America's current and longstanding restrictive immigration policies, plus its sexism, racism, nativism, tribalism, and rising isolationism, all argue against a welcoming Statue of Liberty.

Yet, despite a cavalcade of missteps, Lady Liberty's place as America's "Mother of Exiles" stands. Warts and all, America continues to be the preferred destination of refugees and immigrants worldwide.

Rising at heaven's gate, the Statue of Liberty remains a perfection of art, engineering, and symbolism . . . and this has been her unvarnished tale.

Acknowledgments

This book is a collaboration between two old friends . . . who had lots of help.

Scores of poets, artists, authors, journalists, historians, and photographers inspired and instructed us. And without them these pages surely would be blank. A partial list includes Tyler Ainbinder, Louisa May Alcott, Edward Berenson, Brian Bilston, Umberto Boccioni, Robert Caro, Roger Daniels, Stuart Dim, E. L. Doctorow, Robert Frost, Doris Kearns Goodwin, Woody Guthrie, Pete Hamill, Langston Hughes, Thomas Jefferson, Johanna Johnston, JR, Kathi Kollwitz, Emma Lazarus, Abraham Lincoln, David McCullough, Jon Meacham, Edvard Munch, Jacob Riis, Rembrandt Harmenszoon van Rijn, Arthur Meier Schlesinger, Warsan Shire, David Steinman, Gay Talese, Dylan Thomas, Marvin Trachtenberg, J. M. W. Turner, James Abbott McNeil Whistler, E. B. White, and Walt Whitman.

The process was further accelerated by our publisher, family, and friends.

This is our second book with Fredric Nachbaur and his wonderful staff of professionals at Fordham University Press. We are endlessly grateful for their support, expertise, and friendship.

Joan's daughter, Johanna Ida Dim Rosman, read the manuscript and generously—and gently—offered sage advice and encouragement. Joan's partner, the inestimable Frank A. Rogers, followed her throughout the writing of the book and, as a trained architect, helped her navigate the complex chapter on realization. Joan's cousin

Barry Lippman, raised as a brother, shared his memories of family . . . most particularly of Grandma Ida.

The always brilliant Naomi Levine read the manuscript and made excellent recommendations. Gifted editors Diane Fairbank, Helen Horowitz, and Abigail Johnston, three of Joan's oldest and dearest friends, caught the spirit of the book and helped shape and sharpen the text.

Elizabeth Jorg Masi, Antonio's wife, generously offered advice, guidance, and mentoring. Nicholas Masi, Antonio's brother, shared many memories of their childhood and, most particularly, recalled key details of their voyage to America. Catherine Masi Barbal, Antonio's sister, also shared many memories, most particularly about their mother, Carmela. Artist and dear friend Paul Ching-Bor mentored. And Bates-Masi + Architects provided key technical assistance.

We also had the additional expertise and encouragement of family, friends, and colleagues—truly a village of supporters. Thanks to Sheril Antonio, David Copeland, Phyllis Edelson, Mark and Kay Ethridge, Frye Gaillard, Fern and Stuart Fisher, Stephen Fotter, Dennis Freed, Bill Fuller and Marilyn Yon, Joan Goldsmith, Sunil and Lynn Gupta, Barbara Kancelbaum, Stephen Korba, David Lawrence Jr., Walker Lundy, Kara McGuire, Colleen and Dwight Olson, Carol and Richard A. Oppel Sr., Jeanne and Gordy Rogers, Emma Rosman, Katie Rosman, and Richard Rosman.

Finally, we acknowledge our local libraries. The New York Public Library: The Picture Collection is a gold mine. The Garden City Library was often useful. The Carroll Gardens Branch in Brooklyn features Paul Miklusky, librarian extraordinaire, who followed the book's progress and provided inspired suggestions for the inclusion of poetry.

Clearly, every library needs a Paul

—JMD and AM

Selected Bibliography

Allen, Leslie. *Liberty: The Statue and the American Dream.* New York: The Statue of Liberty–Ellis Island Foundation, Inc., 1985.

Anbinder, Tyler. *City of Dreams.* New York: Houghton Mifflin Harcourt, 2016.

Bell, James B. *In Search of Liberty.* Garden City, N.Y.: Doubleday, 1984.

Berenson, Edward. *The Statue of Liberty: A Transatlantic Tale.* New Haven, Conn.: Yale University Press, 2012.

Bush, George W. *President Bush's Plan for Comprehensive Immigration Reform.* Washington: The White House, 2007.

Chan, Sewell. "Ellis Island's Forgotten Hospital." *New York Times*, October 26, 2007.

Chrishti, Muzaffar. *Post-9/11 Policies Dramatically Alter U.S. Immigration Landscape.* Migration Information Source. Washington. September 8, 2011.

Cohen, D'Vera. "How U.S. Immigration Laws and Rules Have Changed Through History." Pew Research Center, September 30, 2015.

Daniels, Roger. *Coming to America.* New York: HarperCollins, 1990.

Doctorow, E. L. "Introduction." In *Gotham Comes of Age.* New York: Museum of the City of New York, 1999.

Editorial Board. "Donald Trump's Cowardice on Dreamers." *New York Times*, September 5, 2017.

Ellis, Edward Robb. *The Epic of New York City.* New York: Carroll & Graf, 1966.

Gessen, Masha. "Immigrants Shouldn't Have to Be 'Talented' to Be Welcome." *New York Times*, September 6, 2017.

Gjelten, Tom. "The Immigration Act That Inadvertently Changed America." *The Atlantic's Politics & Policy Daily*, October 2, 2015.

Grigsby, Darcy Grimaldo. *Colossal: Engineering the Suez Canal, Statue of Liberty, Eiffel Tower, and Panama Canal.* New York: Prestel, 2012.

Hamill, Pete. *Forever.* New York: Little, Brown, 2003.

Kratz, Jessie. *The Buttonhook.* Ellis Island, N.Y.: National Archives, October 14, 2014.

McCullough, David. *The Great Bridge.* New York: Touchstone, 1982.

Meredith, Howard. *A Short History of Native Americans in the United States.* Malabar, Fla.: Kreiger, 2001.

Mettler, Katie. "'Give me your tired, your poor': The Story of Poet and Refugee Advocate Emma Lazarus." *Washington Post*, February 1, 2017.

Mitchell, Elizabeth. *Liberty's Torch.* New York: Atlantic Monthly Press, 2014.

Nash, Gary. *Revolutionary Founders.* New York: Knopf, 2011.

Petroski, Henry. *Engineers of Dreams.* New York: Knopf, 1995.

Pierce, Sarah. "Immigration under Trump: A Review of Policy Shifts in the Year Since the Election." Migration Policy Institute. December, 2017.

Riis, Jacob A. *How the Other Half Lives.* New York: Dover, 1971.

Robbins, Liz. "Justice Ginsburg Urges New Citizens to Make America Better." *New York Times*, April 10, 2018.

Schlesinger, Arthur Meier. *The Rise of Modern America: 1865–1951.* New York: Macmillan, 1951.

Serwer, Adam. "Jeff Sessions's Unqualified Praise for a 1924 Immigration Law." *The Atlantic's Politics & Policy Daily*, January 10, 2017.

Steinman, David. *The Builders of the Bridge.* New York: Harcourt Brace Jovanovich, 1945.

Trachtenberg, Marvin. *The Statue of Liberty.* London: Penguin, 1976.

Worek, Michael. *An American History Album: The Story of the United States Told through Stamps.* Ontario, Canada: Firefly Books, 2008.

Index

Page numbers followed by an italic *f* indicate paintings.

Abrams, Richard I., 83
African Americans, 14, 41, 56
African immigrants, 57
Alcott, Louisa May, 17
Alexandria's lighthouse, 23
Allen, Leslie, 36
Alsace, France, 20, 25
American Civil Liberties Union, 58
The American Committee, 27, 33, 38
American Dream, 8f
An American Family: A Memoir of Hope and Sacrifice (Khan), 64
American War of Independence (1775–1783), 11, 44
amnesty, for illegal immigrants, 62–63
Anbinder, Tyler, 55, 58
Anglo-Saxon immigrants, 54–55, 61–62, 68
anti-immigration policies, 55, 57–58, 62, 63–64, 68, 84

anti-Semitism, 1–2, 46–49, 56, 57–58, 64, 74
Arrivals, 57f
Asian immigrants, 55, 57, 61–62
The Atlantic, on immigration policies, 61
Aurelius, Marcus, 19
Austria-Hungary immigrants, 55, 68, 74

Bader, Nathan, 53, 64
Baheux de Puysieux, Jeanne-Emilie, 22. *See also* Bartholdi, Jeanne-Emilie
Barnum, P. T., 28
Bartholdi, Charlotte (mother), 20–22, 34
Bartholdi, Frédéric Auguste, 21f; background, 20–22; colossal statuary passion of, 20, 22, 23, 25, 28, 31, 33; early artwork, 22, 23, 25; fundraising by, 20, 25–30, 33, 83; Laboulaye and, 22–23, 25–26, 80, 83; on lighthouse proposal comparison, 23–25, 34; marriage, 12, 22, 34, 41; maternal relationship, 20–22, 34; military service of, 25; Statue of Liberty design and construction by, 31, 32f, 33, 34–38, 40;

Statue of Liberty replica by, 40; Statue of Liberty unveiling by, 12

Bartholdi, Jean Charles (father), 20

Bartholdi, Jeanne-Emilie (wife), 12, 22, 34, 41

Bedloe's Island, 12–14, 25–26, 33, 41

Bell, James B., 83

Berenson, Edward, 18, 23, 38, 83

Bergeron, Claire, 62

Berlin, Irving, 49

The Birth of a Nation (film), 56–57

Booth, John Wilkes, 14

border wall (U.S.–Mexico border), 63, 66

Brandenburg, Broughton, 72

bridge building, 4, 15–17, 16f, 46, 79–80

bridge wire, 15, 46, 80

Brooklyn Bridge, 4, 15–16f, 15–17, 28, 46, 79–80

Brooklyn Bridge, 16f

The Builders of the Bridge (Steinman), 15–16, 79–80

Bureau of Immigration, 68

Button Hook, 70f

Castle Garden, 69

A Century of Dishonor (Jackson), 53

chalk marks, 70–71, 72–73

Chan, Sewell, 71

Chinese Exclusion Act (1882), 55

Chinese immigrants, 55

Chishti, Muzaffar, 62

City of Dreams (Anbinder), 55

civil rights era, 61

Civil War, 22–23, 44, 56, 79–80

Cleveland, Grover, 12, 18, 27, 41

Cleveland Gazette, on Statue of Liberty unveiling, 14, 41

Colmar, France, 22, 25

Colossal: Engineering the Suez Canal, Statue of Liberty, Eiffel Tower, and Panama Canal (Grigsby), 38

colossal statuary, 20, 22, 23, 25, 28, 31, 33. See also Statue of Liberty

Colossi of Thebes (Egyptian statues), 22, 23

Colossus of Rhodes (Greek statue), 38

communist witch-hunts, 58

contagious diseases, 70–71, 74

Conway, Lorie, 71

Cooper, Peter, 20

copper sheathing, 36, 38, 40, 41

Cornwallis, Charles, 11

Daniels, Roger, 63

Declaration of Independence, 11, 18, 34, 53, 64

Declaration of Independence (1776), 11

de Lessep, Ferdinand, 12

Denied, 81f

Department of Homeland Security, 62–63

deportation, 62–63, 71, 73, 74, 75, 81f

depression (1873–79), 44

depression (1929–39), 58

Doctorow, E. L., 46

Donahoe's Magazine, on immigrants' religion, 55

DREAM (Development, Relief and Education for Alien Minors) Act, 62, 63

Dream under Construction, 32f

eastern European immigrants, 55–58, 61

Edison, Thomas Alva, 44

Ed Koch Queensboro Bridge, 4, 46

Egypt, 22, 23

Eiffel, Alexandre Bonickhausen dit, 37

Eiffel, Alexandre-Gustave, 31, 33, 37–38, 41, 83

Eiffel, Catherine-Mélanie, 37

Eiffel Tower, 37

Ellis Island, 49, 57, 58, 69–74, 75

Ellis Island Hospital, 70–71

Emma Lazarus, 47f

Erie Canal, 14

Eternally Vigilant, 82f

European immigrants, 16, 49, 54–58, 61–62, 68

Evarts, William, 12

Everything He Owns on His Back, 52f

Examination, 69f

eye exams, 70f, 73, 74

Fiske, Nathan, 53

Ford, Gerald R., 58

Ford, Henry, 17

Forgotten Ellis Island (Conway), 71

foundation. See pedestal and foundation

Framers, 61

France: Eiffel Tower, 37; gift of Statue of Liberty from, 11, 22–23, 27, 44; immigrants from, 54; passion for Statue of Liberty in, 25, 28, 40, 80, 83; political climate in, 22–23, 25, 33, 34, 44, 83; Statue of Liberty construction in, 31, 32f, 33, 34–38, 40

Francesco, Grandpa. See Grandpa Francesco

franchises (restaurant), 46

Franco-American Union, 25, 33

Frédéric Auguste Bartholdi, 21*f*

freedom and opportunities, for immigrants: Industrial Revolution and, 4, 14–15, 17, 46, 56; in New York City, 2, 4, 7–8, 55–56; promises of, 3–4, 6–8, 46, 53, 64, 65, 83–84; Roebling's story, 15–17, 46, 66–68, 79–80; symbols of, 18, 34, 49, 75, 79, 83–84

French Revolution (1789–1799), 11, 12

Friendship, 10*f*

fundraising efforts, 17–18, 20, 25–30, 33, 34, 83

Future Americans, 44*f*

Gaget, Gauthier et Cie workshops, 33, 34, 40

Gangs of New York (film), 56

Gateway, 60*f*

German immigrants, 54, 58. *See also* Roebling, John Augustus

Germany and German states, 15–16, 25, 58, 66–67

Ginsburg, Ruth Bader, 53

Gjelten, Tom, 61

God Bless America, 78*f*

Golden Door, 67*f*

Goodyear, Charles, 45

Gotham Comes of Age (Doctorow), 46

Gould, Jay, 27

Grandma Ida, 1–4, 3*f*, 56, 79

Grandpa Francesco, 4–5, 6, 56

Grant, Ulysses S., 14, 20, 33

Great Bridge project. *See* Brooklyn Bridge

Great Depression (1929–39), 58

The Great Hall, 72*f*

"Great Wave" immigrants, 56–57, 68

Greeley, Horace, 20

Griffith, D. W., 56

grifters, 73

Grigsby, Darcy Grimaldo, 38

Guthrie, Woody, 77

Henry, Patrick, 11

Hertig, Johanna, 15

Home (Lazarus), 46

hope. *See* freedom and opportunities, for immigrants

Hope of Many, 24*f*

Hungarian immigrants, 55, 68, 74

Hunt, Richard Morris, 38, 41

Ida, Grandma. *See* Grandma Ida

illegal immigration, 62–63

immigrants and immigration: anti-immigration policies, 55, 57–58, 61, 62, 63–64, 68, 84; education levels, 15, 54, 55, 68; illegal immigration, 62–63; national security concerns, 62; opportunities for (*see* freedom and opportunities, for immigrants); processing of immigrants (*see* passing through the portal); pro-immigration reforms, 61–63, 65; reflections on first sighting of Lady Liberty, 3, 7, 79; unrestricted immigration, 18, 54–55, 64. *See also specific places of origin and religions*

Immigration and Nationality Act (1965), 61

Immigration Reform and Control Act (1986), 62

Imported Americans (Brandenburg), 72

In America, 6*f*

Industrial Revolution, 14–15, 17, 20, 44–46, 56. *See also* bridge building

In Search of Liberty (Bell and Abrams), 83

internment, of Japanese Americans, 18, 58

Irish immigrants, 54, 55–56, 61

"Island of Hope," 69, 75

"Island of Tears," 69, 75

Ismail (khedive), 23

isolationism, 56–58, 84

Italian immigrants, 5–8, 55, 57, 68, 74

Jackson, Andrew, 14

Jackson, Helen Hunt, 53

Japanese-American internment, 18, 58

Jewish immigrants, 1–4, 46–49, 53, 56, 57, 58, 74

Joanie and Grandma Ida, 3*f*

John Augustus Roebling, 15*f*

John Roebling's Sons Company, 46

Johnson, Howard, 46

Johnson, Lyndon Baines, 61

Johnson-Reed Act (1924), 57–58, 61, 63

Kennedy, John Fitzgerald, 61

Kennedy, Robert, 61

Khan, Khizr, 64

King, Martin Luther, Jr., 9, 61

Ku Klux Klan, 56

Know Nothing Party, 55

Laboulaye, Édouard René de, 22–23, 25–26, 33, 80, 83

Lady Liberty. *See* Statue of Liberty
Lady Liberty Welcoming, 13*f*
"Lady of the Park," 33
La Guardia, Fiorello, 74
Latin American immigrants, 61–62
Lazarus, Emma, 17, 41, 46–49, 47*f*
Leaves of Grass (Whitman), 17
Lee, Robert E., 14
Lehman, David, 49
liberty. *See* freedom and opportunities, for
 immigrants; Statue of Liberty
Liberty Island. *See* Bedloe's Island
Liberty: The Statue and the American Dream (Allen),
 36, 62, 74
Liberty's Torch (Mitchell), 33
lighthouse proposal, 23–25, 34
Light in the Dark, 48*f*
Light of Liberty, 35*f*
Lincoln, Abraham, 14, 22–23, 44, 56, 79–80
Little Women (Alcott), 17
Longfellow, Henry Wadsworth, 20

Manhattan Bridge, 4
Marshall Plan, 61
Masi, Antonio, 4–8, 74, 79
Masi, Carmela, 6–8
Masi, Francesco. *See* Grandpa Francesco
Masi, Joseph, 5–7
McCarthy, Joseph, 58, 61
Meacham, Jon, 51, 61–62
medical examinations, 69–70*f*, 69–72, 73–74, 73*f*
Meditations (Aurelius), 19
Mediterranean immigrants, 68
Mexican immigrants, 62, 63
Middle Eastern immigrants, 57, 62
Migration Policy Institute, 62
Mitchell, Elizabeth, 33
The Morning News, on Statue of Liberty
 construction, 31
Morton, Levi P., 40
"Mother of Exiles," 84
Mühlhausen, Prussia, 15, 66–67
Muslims, 62, 64

Napoleon III, 22, 25, 33, 34, 83
Native Americans, 18, 53–54
nativism, 55–56, 57–58, 61, 63–64, 84
naturalization ceremony, 53

The New Colossus (Lazarus), 18, 48–49
New Entrepreneurs, 29*f*
New Faces of America, 54*f*
"new wave" immigrants, 55–56, 68
New York (state), 26, 27
New York Bridge Company, 80
New York City: bridges of, 4, 15–17, 16*f*, 46, 79–80;
 dedication parade and ceremony in, 11–12, 15,
 41; fundraising efforts in, 17–18, 27; growth of,
 46; as immigrant destination, 68–70; immigrant
 opportunities in, 2, 4, 7–8, 55–56; location
 choice for Statue of Liberty, 25–26, 33, 41;
 skyline of, 36; weather in, 34, 37–38
New York Stock Exchange, 12
New York Times: on Ellis Island medical
 examinations, 71; on fundraising, 27; on
 Johnson-Reed Act (1924), 58; on naturalization
 ceremony, 53; on Statue of Liberty unveiling, 12
New York Tribune, on France's gift of Statue of
 Liberty, 27
North German Confederation, 25

Obama, Barack, 62–63
Old Country, 5*f*
Opera House dome (Paris), 36
opportunities. *See* freedom and opportunities, for
 immigrants

Page Act (1875), 55
Pale of Settlement, 1–2, 74
Parc Monceau (Paris), 33
Paris, 2, 22, 31, 33, 36, 38–40
Paris Salon, 22
Passing Through, 59*f*
passing through the portal: defined, 49; deportation,
 instead of, 62–63, 71, 73, 74, 75, 81*f*; grifters
 and, 73; immigration centers, 49, 57, 58, 69–74,
 75; La Guardia on, 74; medical examinations,
 69–70*f*, 69–72, 73–74, 73*f*; processing of
 immigrants, 26*f*, 72–75; women traveling alone
 and, 74
patination, 36
pedestal and foundation (Statue of Liberty): design
 and construction of, 38, 41; fundraising efforts
 for, 17–18, 20, 25–30, 33, 34, 83; plaque
 inscription on, 49; Philadelphia Centennial
 Exhibition (1876), 26–27; portal, passing through
 (*see* passing through the portal)

post-9/11 initiatives, 62

Processing, 73f

Protestantism, 55

Prussia, 25, 66–67

Pulitzer, Joseph, 27–28, 83

quarantine, 70–71

Queensboro Bridge. *See* Ed Koch Queensboro Bridge

race and racism, 14, 41, 53, 56–58, 61, 63–64, 84.
 See also anti-Semitism

railroads, 14, 55

Rapp, Jean, 22–23

Reagan, Ronald, 62, 65

Reconstruction era, 14, 44, 56

Reed, David A., 58

refugee issues, 18, 46–49, 58, 62–63, 83–84

Registry Hall (Ellis Island), 72–73, 72f

repoussé technique, 36

restaurant franchises, 46

restrictive quota system, 57–58

The Rise of Modern America (Schlesinger), 56

Roebling, Christoph Polycarpus, 66

Roebling, Friederike, 66–68

Roebling, John Augustus, 15–17, 15f, 46, 54,
 66–68, 79–80

Roebling, Washington Augustus, 15, 79–80

Roebuck, Alvah, 44–45

Roman Catholic immigrants, 55, 56, 61

Roosevelt, Eleanor, 58

Roosevelt, Franklin Delano, 58, 63–64

Roosevelt, Theodore, 73

Rowling, J. K., 17

rubber fever, 45

Russian immigrants, 1–4, 48, 53, 55, 68, 74

Schlesinger, Arthur Meier, 56

Schuyler, Georgina, 48–49

Sears, Richard, 44–45

Sears, Roebuck & Company, 44–45

Second Continental Congress, 53

September 11 terrorist attacks, 62

Sessions, Jeff, 63

Shire, Warsan, 46

slavery, 14

small-time grifters, 73

Smithsonian (magazine), on pedestal inscription, 49

southern European immigrants, 55–56, 57–58

sponsors, for immigrants, 74

statuary, colossal, 20, 22, 23, 25, 28, 31, 33. *See
 also* Statue of Liberty

Statue of Liberty: conception, 11, 22–23, 44,
 80, 83; dedication and unveiling, 11–14, 15,
 41; design and construction, 31, 32f, 33,
 34–38, 40; dimensions and details, 26, 34,
 36, 40; disassembly and reassembly, 40–41;
 French citizens' passion for, 25, 28, 40, 80,
 83; fundraising efforts, 17–18, 20, 25–30, 33,
 34, 83; as gift from France, 11, 22–23, 27, 44;
 immigrants' reflections on first sighting of, 3, 7,
 79; lighthouse proposal comparison, 23–25, 34;
 model for, 34; original name, 11, 33; paintings
 of, 10f, 13f, 21f, 24f, 32f, 35f, 39f, 48f, 82f;
 at Philadelphia Centennial Exhibition, 26–27;
 replica, 40; symbolism, 33–34, 41, 44, 49, 75,
 79, 83–84. *See also* Bedloe's Island; pedestal and
 foundation

The Statue of Liberty: Art in Content (Trachtenberg),
 27

The Statue of Liberty: A Transatlantic Story
 (Berenson), 18

steel cabling, 15, 46, 80

steerage passengers, 1, 3, 7, 68, 70–71

Steinman, David, 15–16, 66, 68, 79–80

Stone, Charles P., 38

Suez Canal, 23

Suez Canal lighthouse proposal, 23–25, 34

suffrage, 12–14, 41

terrorist attacks, 62

"This Land Is Your Land" (Guthrie), 77

Thomas, Dylan, 43

Those Who Came Before, 45f

Those Who Wait, 26f

Tocqueville, Alexis de, 53

torch, 23, 26–27, 34, 35f, 40, 49

Torch of Liberty, 26–27

trachoma, 74

Trachtenberg, Marvin, 27, 28, 49

transportation, modern age of: bridge building, 4,
 15–17, 16f, 46, 79–80; railroads, 14, 55

tribalism, 84

Trump immigration policy, 63–64, 66, 71

Twain, Mark, 17, 18

U.S. Congress, 27, 33. *See also specific immigration legislation*
U.S. Constitution, 18, 64
U.S.–Mexico border wall, 63, 66

Vigilant, 39f
Viollet-le-Duc, Eugène Emmanuel, 34–36, 37–38

wall, at U.S.–Mexico border, 63, 66
Wall Street collapse (1929), 58
Wards Island, 46–48
Washington, George, 11, 27, 64
Washington Monument, 25

Whitman, Walt, 17, 18
Williamsburg Bridge, 4, 46
wire-rope industry, 15, 46, 80
Woman Suffrage Association, 12–14, 41
women's issues, 12–14, 17, 18, 41, 74
World (newspaper): fundraising campaign by, 28, 30, 83; ownership transfer of, 27
World War I, 5, 56–57
World War II, 5–6, 18, 58, 61, 64
"wretched refuse," 18, 68

Young, Brigham, 20

Joan Marans Dim is a historian, novelist, and essayist. Her published work includes the novel *Recollections of a Rotten Kid*. She also has co-written two histories—the saga of New York University, *Miracle on Washington Square*, and, most recently, *New York's Golden Age of Bridges*. Her essays and op-eds have appeared in the *New York Times*, the *New York Daily News*, *Barron's*, *Investor's Business Daily*, *The Huffington Post*, and many other publications. She also participated in the *New York Times* video *City Living: A Tale of Two Bridges*. Critics, citing the scope and depth of her work, describe her prose as laced with impressive depth, a droll wit, and an elegant narrative.

Antonio Masi is a world-class and award-winning artist often honored for his depictions of bridges; his magnificent paintings are exclusively featured in the book *New York's Golden Age of Bridges*. Masi is also president of the American Watercolor Society. His artistry has been featured in *Artists Magazine*, *PBS–Sunday Arts*, *NBC-Today*, *Newsday*, and many other venues. He also participated in the *New York Times* video *City Living: A Tale of Two Bridges*. A sought-after artistic master and scholar, he travels the world as a teacher, demonstrator, and lecturer.

EMPIRE STATE EDITIONS

Select titles from Empire State Editions

Patrick Bunyan, *All Around the Town: Amazing Manhattan Facts and Curiosities, Second Edition*

Salvatore Basile, *Fifth Avenue Famous: The Extraordinary Story of Music at St. Patrick's Cathedral*. Foreword by Most Reverend Timothy M. Dolan, Archbishop of New York

Andrew J. Sparberg, *From a Nickel to a Token: The Journey from Board of Transportation to MTA*

New York's Golden Age of Bridges. Paintings by Antonio Masi, Essays by Joan Marans Dim, Foreword by Harold Holzer

Daniel Campo, *The Accidental Playground: Brooklyn Waterfront Narratives of the Undesigned and Unplanned*

Gerard R. Wolfe, *The Synagogues of New York's Lower East Side: A Retrospective and Contemporary View, Second Edition*. Photographs by Jo Renée Fine and Norman Borden, Foreword by Joseph Berger

Joseph B. Raskin, *The Routes Not Taken: A Trip Through New York City's Unbuilt Subway System*

Stephen Miller, *Walking New York: Reflections of American Writers from Walt Whitman to Teju Cole*

Tom Glynn, *Reading Publics: New York City's Public Libraries, 1754–1911*

R. Scott Hanson, *City of Gods: Religious Freedom, Immigration, and Pluralism in Flushing, Queens*. Foreword by Martin E. Marty

Dorothy Day and the Catholic Worker: The Miracle of Our Continuance. Edited, with an Introduction and Additional Text by Kate Hennessy, Photographs by Vivian Cherry, Text by Dorothy Day

Pamela Hanlon, *A Wordly Affair: New York, the United Nations, and the Story Behind Their Unlikely Bond*

Nandini Bagchee, *Counter Institution: Activist Estates of the Lower East Side*

Elizabeth Macaulay Lewis and Matthew M. McGowan (eds.), *Classical New York: Discovering Greece and Rome in Gotham*

Susan Opotow and Zachary Baron Shemtob (eds.), *New York after 9/11*

Andrew Feffer, *Bad Faith: Teachers, Liberalism, and the Origins of McCarthyism*

Colin Davey with Thomas A. Lesser, *The American Museum of Natural History and How It Got That Way*. Foreword by Kermit Roosevelt III

Lolita Buckner Inniss, *The Princeton Fugitive Slave: The Trials of James Collins Johnson*

Wendy Jean Katz, *Humbug: The Politics of Art Criticism in New York City's Penny Press*

Thomas J. Shelley, *Upper West Side Catholics: Liberal Catholicism in a Conservative Archdiocese*

For a complete list, visit www.fordhampress.com/empire-state-editions.